CONTEMPORARY PAINTING

CONTEMPORARY PAINTING

by Paul Vogt

Director, Folkwang Museum, Essen

Translated from the German by Robert Erich Wolf

HARRY N. ABRAMS, INC., PUBLISHERS, NEW YORK

Editor: Donald Goddard
Designer: Linda Schifano
Rights and Reproductions: Eric Himmel

Library of Congress Cataloging in Publication Data

Vogt, Paul, 1926–
 Contemporary painting.

 1. Painting, Modern—20th century. I. Title.
ND195.V5713 759.06 81-68
ISBN 0-8109-0780-1

Published in 1981 by Harry N. Abrams, Incorporated, New York

Printed and bound in Japan

PHOTOCREDITS: Martien F. J. Coppens, Eindhoven, fig. 7; Scott Hyde, New York,
fig. 23; Walter Klein, Düsseldorf, figs. 6, 16; Robert E. Mates, New York, fig. 15; Pace
Gallery, New York, pl. 48; David Preston, New York, pl. 21; Rheinisches Bildarchiv,
Cologne, fig. 3; Walter Russell, New York, fig. 22; John Tennant, Washington, D.C., pl.
5; Malcolm Varon, New York, pl. 2; Liselotte Witzel, Essen, figs. 1, 2, 10, 11

CONTENTS

INTRODUCTION

A book proposing to describe the development of painting in Europe and the United States after 1945 requires an explanation of the principles on which it is based. There has been no attempt to present either a scholarly investigation or a complete treatment of recent artistic phenomena, which, in a book of this length, would have meant at best a superficial listing of names and dates. The pictures and text are meant, rather, to enable the reader to glimpse the multiplicity of expression over the past four decades, emphasizing those works in which specific tendencies of the time appear especially clearly, with the artist and his work occupying the most important place. This introduction intends simply to point out those orientation points from which the overall situation can be surveyed. Admittedly, this involves a selection from the many available possibilities. But in the face of the tremendous range of artistic processes that have emerged and the complexity of the external forms they have assumed, one might question whether, in a time which asks more about the social function and relevance of art than about its aesthetic or historical development, an approach dictated by the traditional concept of a linear development can still be adequately elucidated, especially in a generally understandable terminology.

Even the term "painting," once nearly synonymous with "art," suffices for only a limited slice of what we mean by art today. True, it retains its importance for the period immediately after World War II—the years of Abstract Expressionism and Tachisme—when the artist's efforts to come to grips with his inner and outer worlds were fought out on canvas or some other traditional support. But by the late 1950s, at the latest, the reign of the easel painting had come to an end. There will, no doubt, be artists in years to come who will still find easel painting the most effective medium for their conceptions. But for some time now the aim of most advanced artists has been to go beyond the traditional concepts, to break down the barriers between art and life. Small wonder, then, that viewers too have been compelled to a fundamental change in point of view.

Nonetheless, this book is about painting, though not so narrowly as not to find room for certain extensions of the term. Günther Uecker's nail-pictures (fig. 1), Lucio Fontana's slashed canvases (fig. 2), and Arman's constellations of paint tubes (colorplate 36) all involve creative processes connected with painting. There are other artists, however, who have exerted considerable influence on the mental set and climate of our time—I am thinking of Joseph Beuys, for one—and yet have no place in a book on painting after 1945. Proof, then, of how little painting can still lay claim to a general validity if really important artists are not to be counted as

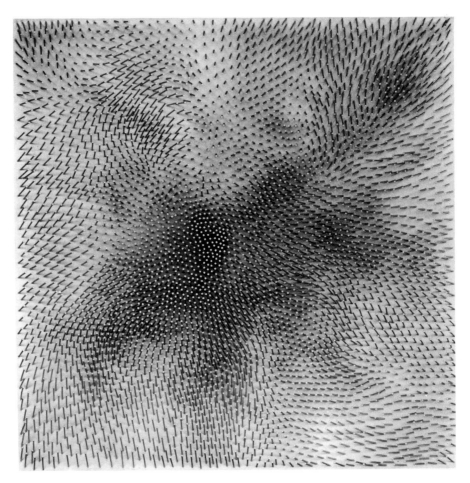

1. Günther Uecker (b. 1930). *Large White Field.* 1970. Nails and canvas, 59 × 59 × 5 ⁷/₈″ (150 × 150 × 15 cm). Folkwang Museum, Essen

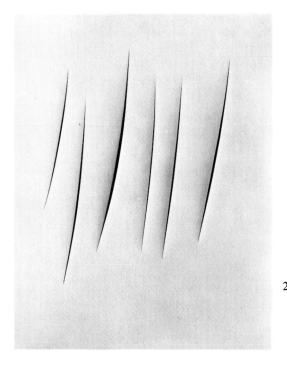

2. Lucio Fontana (1899–1968).
Spatial Concept "Attese."
1959. Canvas, 36 × 28 $\frac{3}{4}$"
(91.5 × 73 cm). Folkwang
Museum, Essen

painters and if, to classify what they do, one has to find new mental pigeonholes.

One might also question whether national identity is any longer a valid point of departure in defining the accomplishments of artists, whether that has not been replaced by systems of international connections. No doubt there will always be artists who draw on national or folk sources. But a brisk give and take among countries has long made the old boundaries, the national ones as well, obsolete. Every artist is exposed to a virtually unlimited field of intercommunication, and impulses of an international character have become the rule everywhere. One need not look far in postwar art for proof.

Thus, with full awareness of the problems, this book takes as its basis the only authentic source—the work itself. A work of art mirrors the psychological and intellectual tensions of the times, the impulses and ideas and concepts that leave their mark on any particular period. A picture in a book cannot answer all the questions that arise when one is face to face with the original work of art, but it can serve as a guide to that adventure of mind and spirit with which the author himself, in his activities in a museum of contemporary art, finds himself confronted anew each day.

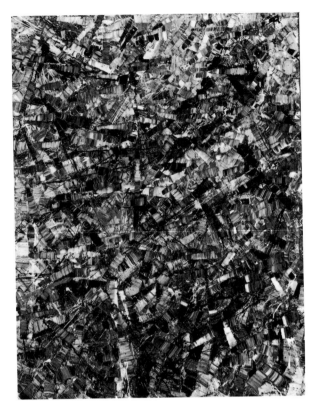

3. Jean Paul Riopelle (b. 1923).
Composition in Blue. 1954. Oil
on canvas, 45 $^5/_8$ × 35″ (116 ×
89 cm). Wilhelm-Hack-Museum,
Ludwigshafen

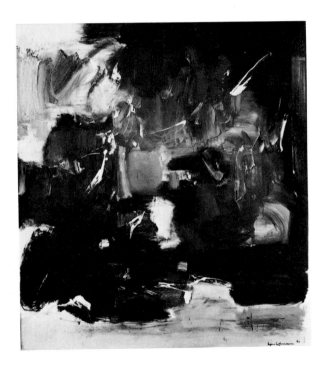

4. Hans Hofmann (1880–
1966). *Summer Night's
Bliss*. 1961. Oil on canvas,
84 × 78″ (213.4 × 198 cm).
Baltimore Museum of Art.
Gift of the Artist

THE FOUNDATIONS OF POSTWAR PAINTING

When the artistic situation in Europe after 1945 gradually began to reveal itself, it proved to be very different from that of the prewar years. The emphasis was no longer, as it had been in the 1920s and '30s, on the various ways nature could be interpreted (which was by no means identical with the pseudo-realism promoted by the dictators). The trend was unequivocally toward abstraction. This was not an entirely new orientation, but a renewal of ideas that had been developed long before World War II by such artists as Kandinsky, Klee, and Mondrian. Even during the period of totalitarianism, that dark span when men and ideas were without homes and places in which to thrive, the impulses sparked off in the work of the pioneers had continued to smolder. Here and there individual artists kept the ideas of their predecessors alive as goals they never ceased to strive for. And what seemed isolated intellectual achievements turned out to be, after the war, part of a new and unified pattern, a comprehensive concept of development that ignored the boundaries between one country and another. Even American art, of which prewar Europe had scarcely been aware, fit seamlessly into the general tendency and made its independent but no less productive contribution.

The key centers of artistic activity when peace returned were Paris and New York. The French metropolis reasserted its position as international leader and drew into its orbit artists from overseas such as Jean-Paul Riopelle from Canada (fig. 3) and Sam Francis from the United States (colorplate 10). The first exhibitions after 1945 were still dominated by the established modern masters—Picasso, Braque, Chagall, Miró, Léger—and their authority was at first unchallenged and an obstacle to any real change. Meanwhile, artists of the younger generation committed themselves to nonobjective art, which had played scarcely any role in France before the war but was now emerging as the preeminent style. Paris, unlike Germany, retained a connection with the prewar period in the Abstraction-Création group, which was formed in the early 1930s and continued to be the rallying point for various abstract currents. Yet the decisive stimuli for a new abstract painting did not come from this group but from a circle of young French painters who, in the occupied Paris of 1941, had come forward with a polemical exhibition bearing the challenging title "Peintres de tradition française." Prominent among these artists were Alfred Manessier (colorplate 13), Maurice Estève, Jean Le Moal, Gustave Singier, Jean Bazaine (fig. 7), and Charles Lapique.

American painting up to 1945 was thought of as an offshoot of European painting. Emigrants from the old continent, after escaping the war in

Europe, had for some years been setting the pace in the artistic life of New York. Marc Chagall, Fernand Léger, Max Beckmann, Piet Mondrian, Marcel Duchamp, Max Ernst, Salvador Dali, Roberto Matta (colorplate 1), Yves Tanguy, and André Masson had an important and widespread influence. Two Germans, Hans Hofmann (fig. 4) and Josef Albers (colorplate 29), had an equally durable impact on the younger generation through their teaching. It was only natural, then, that the men who initiated the new American painting—Jackson Pollock, Willem de Kooning, Arshile Gorky, Mark Rothko, Robert Motherwell, and others—should begin with notions developed in prewar Europe, notions that would assume even greater importance in artistic thinking after the war, alongside indigenous ideas that could stand on their own.

In Germany the situation was much less propitious. Dictatorship and war had crushed a once flourishing modernism, driving its leading talents out of the country and snapping all links with the immediate past. Only in the work of a few artists, such as Willy Baumeister and Ernst Wilhelm Nay (colorplate 17), was there a continuity in development between the prewar and postwar worlds. Nevertheless, by the end of the 1940s the generation on its way up was already part of the same polarization that existed in other Western countries, and the best among them had opted for abstraction.

Italy also joined in the swing to nonfigurative art, contrary to expectations, though not even the most committed of its modernists could claim that the tendency sank particularly deep roots. Even so, it could count on such strong postwar talents as Giuseppe Santomaso, Afro, and Emilio Vedova (colorplate 21).

England between the wars had made no noteworthy contribution to European art. Now, however, it broke out of its isolation. Artists such as Ben Nicholson (colorplate 28), Graham Sutherland, and Francis Bacon (colorplate 27) represented a genuine English achievement which in the next generation would swing even more weight on the international scene.

THE 1950s

Abstract Expressionism, Action Painting, Art Informel, Tachisme—these were the terms that were adopted and naturalized for a myriad of postwar approaches that encompassed figuration and association with object or subject as well as a very different kind of art produced only through psychological improvisation or free gesture. The first two terms apply essentially to the highly expressive painting practiced in the United States from 1945 on, whose dramatic impetus had a lasting effect on European

painting. The latter two terms apply chiefly to the European situation around and after 1950. For all their formal distinctions, the two tendencies had a good deal in common. Both aimed to give visual evidence, in the guise of spontaneous traces of the act of painting itself, of tautly-spanned moments in human existence. This meant endowing the artist's own existence—which mirrored the spiritual unrest of an entire epoch—with a new-found arsenal of communicatory signs. Such unprecedented freedom in creative self-expression fascinated the public as well as the artists. At the same time it changed the traditional concept of what a picture is. The painter was no

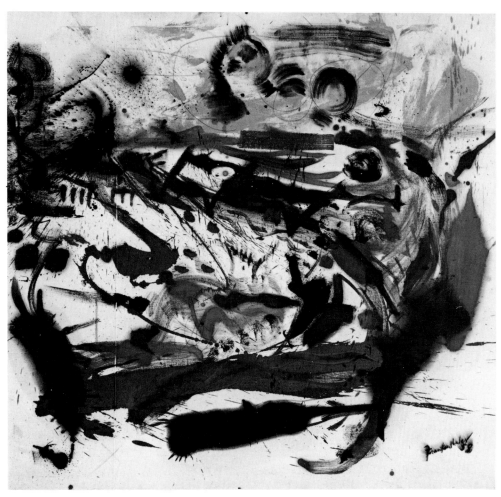

5. Helen Frankenthaler (b. 1928). *Hudson Valley*. 1958. Oil on canvas, 45 $^1/_2$ × 49 $^1/_2$″ (115.6 × 125.7 cm). Collection of the artist

longer working toward a preplanned, preprogrammed goal: a *picture*. What he was doing now remained open-ended: an *action*. Painting itself had become an existential act, the real and sole content of an entirely new kind of painting. The picture became a metaphor for one man's fate (Wols, colorplate 15), the canvas a ground on which to meditate and on which agitated linear diagrams could stand like notations of an inner excitement (Hartung, colorplate 16). And, it appeared, only abstract art was capable of realizing metaphors of such intensity, of evolving personal scripts of psychological immediacy entirely unhampered by pictorial anecdote and literary content. Carried to its limits, the picture did not *picture*, did not hold up to view preconceived forms. On the contrary, it was no less but no more than the record of how one man, a painter, could give vent to forces within him; it was *informel*, or unshaped, unformed—picture as painting.

This change in the concept of a picture was attended by changes in the process of painting and in the technical means. Just how far artists were moving away from tradition is evident in the fabric of lines and spots (thus Tachisme, from *la tache*, or "spot") that Wols used as a vehicle for the utmost psychological expressive capacity; in Jackson Pollock's method of dripping with thin paint trickled through a hole in a can or spattered from a brush onto a canvas lying on the floor, so that the painter no longer "painted" but "acted," standing on and inside his picture (colorplate 5); in the sensitive calligraphic tracings of Mark Tobey (colorplate 11); and in the swirling and slashing diagrams of Hans Hartung. Yet deep as it went, the break with tradition was by no means total. If everywhere one found the limits pushed back almost to the point of no return thanks to a new definition of the relation between the artistic ego and the world, easel painting nonetheless continued to be the medium in and field on which to play out those conflicts. The final break remained for the 1960s.

The new American painting was introduced to Europe in 1948 in exhibitions organized by Peggy Guggenheim and soon afterward by certain Paris galleries, and three years later Berlin showed a more extensive survey. The United States was girding to take over world leadership in art. Still, American as Abstract Expressionism might be, the strongest motive force behind it had been the European Surrealism that had left its mark on the New York scene. What Arshile Gorky was doing by 1947 (colorplate 2), and the character of the early work of Robert Motherwell (colorplate 4) were formed under the influence of Surrealism, particularly that of Roberto Matta (colorplate 1), who returned to Europe in 1949. Pollock, Rothko, Newman, and many others were indebted to the movement in the formation of their own unique styles.

The central figure of the period was Jackson Pollock. In his works un-formal painting achieved its earliest and most lasting expression. The picture was transformed from image to event; the age-old way of reading a picture in terms of top and bottom, left and right, was made obsolete; illusionistic spatial perspective was abolished; the whole "art" of painting was denied in favor of action. There were notable partisans of two trends within Abstract Expressionism: those who staked all on dramatic gesture, like Pollock, Franz Kline (colorplate 6), and Willem de Kooning (color-plate 3); and those, like Mark Rothko (colorplate 7) and Barnett Newman (colorplate 8), who were attuned to something more meditative. These pioneers were joined later by Helen Frankenthaler (fig. 5), who was one of the few really important talents of the second wave. Artists in the rest of the United States were still in the shade of the overtowering New York scene. In 1950, however, Clyfford Still (colorplate 9) emigrated to New York and Sam Francis (colorplate 10) to Paris, both from California. Significantly, color dominates over expression in the work of these westerners.

Until almost the close of the 1950s the École de Paris remained the

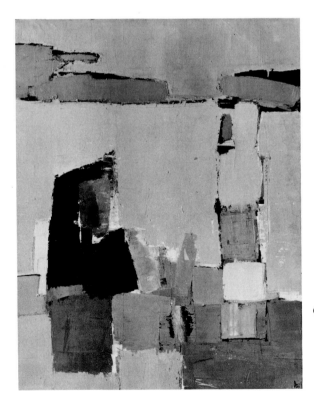

6. Nicolas de Staël (1914–55). *Figure at the Seashore*. 1952. Oil on canvas, 63 ⁵/₈ × 51″ (161.5 × 129.5 cm). Kunstsammlung Nordrhein-Westfalen, Düsseldorf

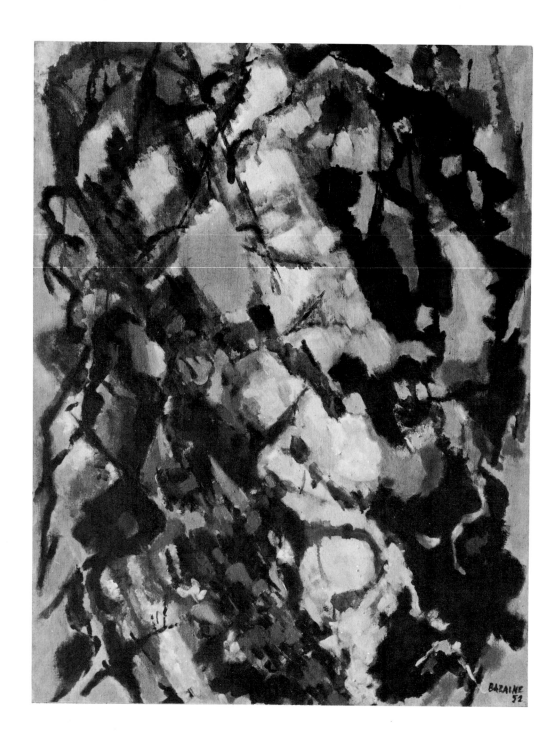

7. Jean Bazaine (1904–75). *Orage au jardin*. 1952. Oil on canvas, 39 $^3/_8$ × 31 $^7/_8''$
(100 × 81 cm). Collection Van Abbemuseum. Eindhoven

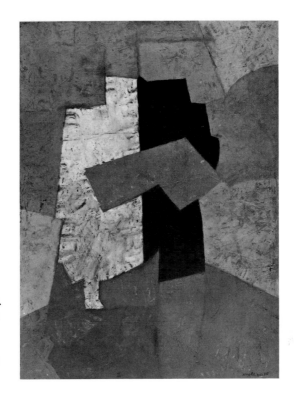

8. Serge Poliakoff (1906–69).
Composition. 1950. Oil on
wood, 51 $^3/_8$ × 38 $^1/_4''$
(130.5 × 97.2 cm). The
Solomon R. Guggenheim
Museum, New York

European focal point for abstract art and could still hold its own against
the transatlantic advance. What mattered in Paris was less expressionistic
action than *engagement*: total commitment to the expression of a feeling
that everything that exists is part of everything else, whether in nature or
in spirit. By and large it is as a Latin contribution to abstraction that we
must understand the attempt to translate the experience of the world into
an abstract system of resonance and counter-resonance (De Staël, fig. 6)
and the attempt to interpret color and light and their inherent association
as symbols of direct emotional involvement in the presence of things seen
or experienced (Manessier, colorplate 13; Bazaine, fig. 7). Latin, likewise, is
the emphasis on the aesthetic side of painting, on what is implied in the
word *peinture*, the very thing that American critics, in the pride of
their Action Painting, have often mistakenly belittled as "narcissism"
and "drooping vitality"—a condemnation that burdens the masters with
the faults of their innumerable epigones and overlooks how firmly
that tendency too is rooted in the French tradition of painting.

In Germany, where art is in any case understood more as metaphysi-
cal necessity than as a process of making and shaping, the expressive
position of the new approach coincided with the native tradition of art as
expression, and so elicited an ardent response. The guiding spirits for the

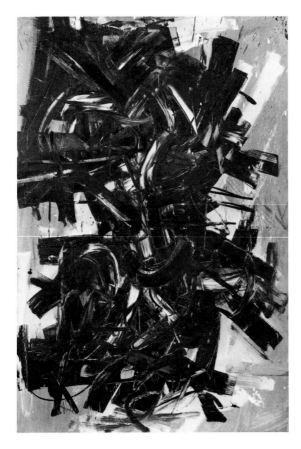

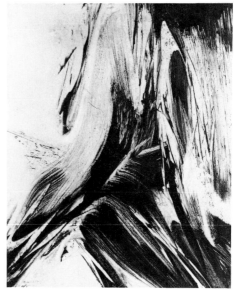

9. Antonio Saura (b. 1930). *Untitled.* 1957. Oil on canvas, 76 $^3/_4$ × 51 $^1/_8$″ (195 × 130 cm). Folkwang Museum, Essen

10. Karl Otto Götz (b. 1914). *Bran-Bild vom 25. 11.57.* 1957. Oil on canvas, 57 $^1/_4$ × 47 $^3/_8$″ (145.5 × 120 cm). Folkwang Museum, Essen

young generation were Wols, Hartung, and Pierre Soulages (colorplate 14), all based in Paris. From Pollock they learned a freedom of handling paint and a use of spontaneous gesture which, for many of them, proved both stimulating and dangerous.

The rallying points became the Munich Zen 49 group led by Fritz Winter and the Frankfurt Quadriga group, whose first exhibition in December 1952 established Tachisme in Germany as neo-Expressionism, notably in the work of K.O. Götz (fig. 10) and Bernard Schultze (colorplate 19). Most artists took up an individual stance within the divergent abstract trends, as we see with K.R.H. Sonderborg (colorplate 20) and Emil Schumacher (colorplate 18). Among the most important loners was E.W. Nay (colorplate 17), whose development from expressionistic representation to the concrete *gestalt*, a development based primarily on the medium of color, is as exemplary as it is unique in Germany.

A fantastic and unbridled expressionism was practiced by the members of the CoBrA group (so named from abbreviations for their re-

11. Gerhard Hoehme (b. 1920). *Roman Letter*. 1960. Oil and collage on
canvas, 84 ⁵/₈ × 120 ¹/₈″ (215 × 305 cm). Staatsgalerie, Stuttgart

spective home cities of Copenhagen, Brussels, and Amsterdam). In the
works of the Dutchman Karel Appel (colorplate 22), the Belgian Pierre
Alechinsky (fig. 12), and the Dane Asger Jorn (colorplate 23), figurative
elements crop up like surprising accidents from a violently impetuous
brushwork. These artists cannot deny indigenous origins that go back to
Hieronymus Bosch and James Ensor, and to the Nordic myths of nature
demons.

Precisely during this phase of the 1950s, with its emphasis on expres-
sion, there were other important figurative currents in European painting.
That there was no single style was proof that traditional roots and the chal-
lenges of the moment could still be reconciled. The question of whether the
impulse originated in Expressionism or New Realism or Surrealism—
which in Vienna garnered an important following among artists like
Rudolf Hausner (fig. 13)—was really of secondary importance, especially
with artists such as the Swiss Alberto Giacometti (colorplate 26) and the
Englishmen Graham Sutherland and Francis Bacon (colorplate 27), whose

incentive came from forces by and large identical with those motivating the abstractionists.

The increasingly independent role played by the means of painting themselves is yet another trait of the time that goes beyond the traditional concept of painting. A few artists—Antoni Tàpies for one (colorplate 25)—recognized that the surface of a picture could be manipulated and exploited, without the detours involved in painting as such, by introducing and reworking such materials as asphalt, sand, plaster, and straw, thus creating a highly evocative ground that could be utilized as a formal as well as expressive factor. Furthermore, as Jean Dubuffet demonstrated so ably in his Art brut (colorplate 24), this approach could also act as provocation directed against the traditional idea of what a picture should be. Such works in fact illustrate what the proponents of the *informel* were after when

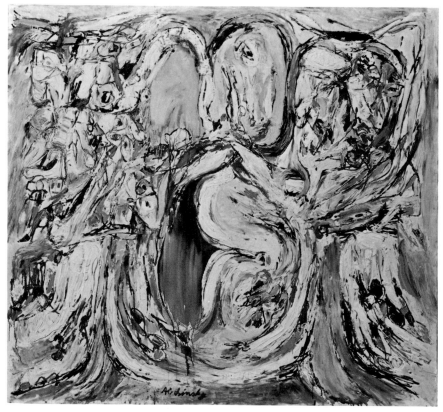

12. Pierre Alechinsky (b. 1927). *Le vert naissant*. 1960. Oil on canvas,
72 $^1/_2$ × 80 $^3/_4$″ (184 × 205 cm). Musée Royal d'Art Moderne, Brussels

13. Rudolf Hausner (b. 1914). *Adam Massiv*. 1968–69. Oil on canvas, fitted on Novopan, 40 $\frac{1}{4}$ × 28 $\frac{3}{8}$″ (102 × 72 cm). Collection M. and P. Infeld, Vienna

14. Paul Wunderlich (b. 1927). *Aurora (Hommage à Runge)*. 1964. Tempera on canvas, 63 × 51 $\frac{1}{8}$″ (160 × 130 cm). Kuns halle, Hamburg

15. Alan Davie (b. 1920). *The Golden Drummer Boy No. 2*. 1962. Oil on canvas, 68 × 84″ (172.7 × 213.4 cm). The Peggy Guggenheim Collection, Venice. The Solomon R. Guggenheim Foundation

they called for painting liberated from every last classical rule. At the same time, works like these marked a beginning toward thinking of the picture as an object in itself, an almost inevitable development considering the ever more conspicuous sheer material character of the picture ground.

It is scarcely possible to trace all the lines of development of those years. If one looks for what they had in common, it was most likely the notion of painting as a psychological activity that attempts to transform the impulses arising out of the inner and outer realms of human experience into pictorial responses, and aims therewith to replace the traditional concept of a picture and its representational character with the subjective sign as documentary record of intellectual and psychological experience. It is true, as Werner Haftmann points out, that abstract painting after 1945 had shown itself to be an internationally accepted process of taking possession of the world and mastering it. Yet, already in the mid-1950s forces were stirring against such emotionalizing of color and form, against subjectivism, against the notion that the language of art was entirely free and uncommitted, and above all against the drift toward the merely decorative in which Tachisme was all too visibly petering out. Abstract Expressionism and Art Informel both came to an end precisely because they proved incapable of handing on convincing arguments that would serve to guide a new generation already waiting in the wings. For all the sheer greatness of the earlier masters, they had little to offer beyond what they achieved themselves.

PAINTING AFTER 1960

In the 1960s, unlike the 1950s, there was no common bond setting all of art on a common path. The new slogan was "pluralism." Movements like Op and Pop, New Concrete Art, Hard Edge, and Photorealism were international in scope. They forced the public to skip nimbly from one argument to the next, to forget about any single and generally applicable point of view, to look at everything from and in a perspective of constant change. Painting might still be some sort of general territory, but the days were gone when it was the field on which new concepts were tried and paraded. Questions about what one country or another was achieving likewise became purely incidental. Instead of serving as foci of familiar lines of development, the major art centers were at most orientation points from which to size up this situation or that; continents, not cities, carried the trends.

Already in the 1950s, and alongside the prevailing Action Painting, there was a special accent in the United States on hard-edge abstraction,

which rejected everything related to expressive effect in favor of objectifying color and form. Compare the works of Pollock or Kline with those of Ellsworth Kelly (fig. 16) or Frank Stella (colorplate 30). With the latter two neither paint nor color is equated with expressiveness. Color has *become* form, and the entire picture surface is articulated as a single field.

As early as the 1920s, painters like Mondrian had sought to suppress all evidence of the human hand, an inevitable component of oil painting. Newman and Stella, in his early period, tried to do likewise, aiming at a kind of painting free of emotions and subjective treatment. For the artists of the 1960s, newly discovered mediums such as acrylic paints meant that a canvas need no longer be painted but could literally be *colored*—uniformly suffused with color—and it was precisely this unpainterly use of paint that made colors more intense. Color surfaces laid on in this way meet cleanly and sharply, in a *hard edge*, and any unpainted canvas between them appears as a void or a negative form. A picture could now be considered a

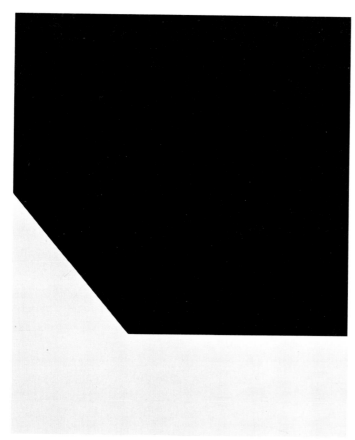

16. Ellsworth Kelly (b. 1923). *Black/White*. 1976. Oil on canvas, 94 $^1/_2$ × 86 $^5/_8$″ (240 × 220 cm). Kunstsammlung Nordrhein-Westfalen, Düsseldorf

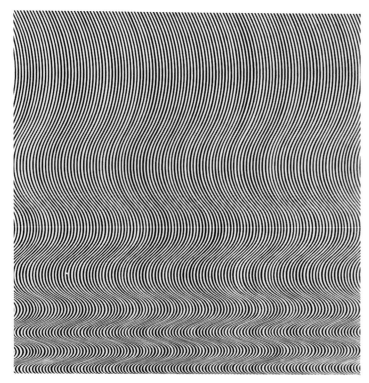

17. Bridget Riley (b. 1931). *Fall*. 1963. Acrylic on board, 55 $\frac{1}{2}$ × 55 $\frac{1}{4}$″ (141 × 140.3 cm). The Tate Gallery, London

18. Jan Schoonhoven (b. 1914). *R 70–61 1970*. 1970. Wood and paper, 41 $\frac{3}{4}$ × 41 $\frac{3}{4}$″ (106 × 106 cm). Folkwang Museum, Essen

thing, something in itself and unrelated to anything else. Inevitably, then, the whole tradition of the rectangular canvas became obsolete. The color fields themselves determined the form of the picture, resulting in *shaped canvases* (colorplate 30). On the other hand, the physical and optical properties of colors remained unchanged, and their relations to each other now became the point of emphasis, taking the place of traditional content or the more recent element of physical gesture.

Certainly hard-edge painting had historical antecedents in the late cutouts of Matisse, the color experiments of Josef Albers (colorplate 29), the ideas of the prewar Constructivists. But the absolute coolness, the lack of passion, the finality of hard-edge painting strike us today as characteristic of the American scene, and were so understood by its initiators, by Newman for one (colorplate 8). Because of its doctrinaire absolutism, however, this current did not become as widespread as, for instance, Action Painting, though it had its impact in England and Germany and found all-out adherents there. It is best understood in connection with comparable movements that aimed likewise at freeing painting of everything outside painting itself—outside all nonvisual elements—in order to "get away from

19. Roman Opalka (b. 1931).
OPALKA 1965 /1–∞
Détail 680350–707495
1965. Acrylic on canvas,
79 $^1/_2$ × 59 $^7/_8$″ (202
× 152 cm). Folkwang
Museum, Essen

the idea of art," as Yves Klein put it. Since modern art took its first steps, some such approach has repeatedly put itself up for debate.

It is in this respect, and in their exclusive concern with the viewer's eye, that despite their different goals hard-edge and Op art meet. In Op art—that is, optical art—pictures and objects are devised for purely visual contact between artwork and viewer. Unstable optical effects are elicited through physical phenomena, either by movement of or in the work itself (in fact or illusionistically) or from the slightest movement made by the viewer. These excitations of the optic nerves come about only through the active involvement of the viewing eye (Bridget Riley, fig. 17).

The Zero group in Düsseldorf began to concern itself with these problems in 1957, initially still in terms of painting on canvas. They recognized that the qualitative properties and conditions of the materials of painting can be used to organize the picture surface rhythmically or texturally in conformity with the laws of vision. Even monochromatic surfaces can provoke such effects if the artist organizes pure optical data into new objective relationships in accordance with a preestablished concept (Heinz Mack, colorplate 33), and the approach is broad and flexible enough even to allow for wit (Yves Klein, colorplate 37). Disturbances—irritations—built into synthetic pictorial structures that are regularly laid out and colored can be set up to exploit visual principles and optical sensations (Victor Vasarely, colorplate 35). It goes almost without saying that Op art and Kinetic art (objects which move on their own or give the illusion of movement) are very much a part of our contemporary

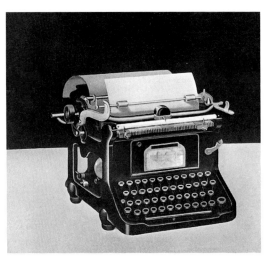

20. Konrad Klapheck (b. 1935). *Typewriter*. 1955. Oil on canvas, 23 $^5/_8$ × 29 $^1/_8$" (60 × 74 cm). Collection of the artist, Düsseldorf

21. Larry Rivers (b. 1923). *Dutch Masters & Cigars*. 1963. Oil and collage on canvas, 96 × 67 $^3/_8$" (243.8 × 171.1 cm). The Harry N. Abrams Family Collection

26

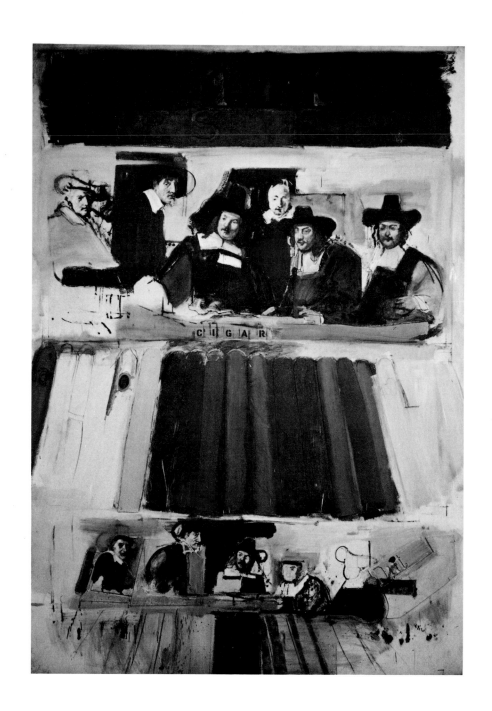

22. Arakawa (b. 1936). *Mona Lisa*. 1967–68. Oil and photo collage on
canvas, 92 × 66″ (223.7 × 167.6 cm). Collection of the artist

fixation on technology. It is now difficult to make an unequivocal distinction between object and picture, especially since painterly effects can be evoked by means that have nothing to do with paint (Günther Uecker, fig. 1).

After 1960 the whole matter of a new definition of reality began to cover a much broader range, and this was at the very point when abstract art was at its most flourishing in both Europe and the United States. In 1955, with a royal unconcern for what was going on everywhere, Jasper Johns painted a series of American flags in which the emphasis slowly shifted from image to object until at last both fused in a new identity vacuumed of all emotion (colorplate 41). That same year Konrad Klapheck, who was still a student at the Düsseldorf Akademie, produced a picture of a typewriter distinguished by a "prosaic superobjectivity" (fig. 20) as his way of proclaiming his opposition to Tachisme. As incunabula of contemporary art, both works take unique positions in relation to all previous figurative painting: with Johns, the *reality-connection* between art and life; with Klapheck, the *thing-magic* of reality.

Meanwhile, in Paris, a new group formed in 1960 with the rather worn-out battle cry of Nouveau Réalisme. Artists, they held, no longer wished to depict reality but instead, through selection and arrangement, aimed to put together new things that would be more real (Arman, colorplate 36). The idea was not new. It was based on the Dada proposal that a thing, without the intervention of anything "artistic" but merely by combination or isolation, could be made to look like part of a kind of new mythology. There were prototypes in Marcel Duchamp's "Readymades," the everyday objects he removed from everyday contexts and proclaimed to be works of art. With pioneers and later adepts alike, the outlook and aim was antiartistic and antiaesthetic, even if, whether they liked it or not, the fantastic counter-reality of such object-fetishes easily took on a Surrealist cast which, accordingly, neatly put them back into the proper domain of cultured art.

Pop art, the most popular trend among all these new realisms, did not play the Dada game of putting reality on show. Instead, in the most banal manner possible, it went right to the point. Pop art was a child of the Big City—a *kid* showing the trivial other face of modern life with its here-today-gone-tomorrow status symbols. An iconography assembled out of everybody's everyday objects, impressions, and clichés conjured up a cheeky and to-the-point stage show of our present world of publicity and consumption in opposition to any and every poetically heightened view of reality. England may have mothered and baptized this "popular" art, but it was certainly no made-in-Europe product—or, only insofar as post-

war Europe scarcely could or did resist the massive temptation of America's consumer culture. Among its founding fathers, if one may venture the term, were David Hockney (colorplate 40) and Allen Jones (colorplate 38) along with the American R. B. Kitaj (colorplate 39), all of whom were students at the Royal College of Art in London in the early 1960s. With Pop art the English finally shook off their virtually traditional isolation in art matters and joined the international scene.

Much more than in Europe, Pop art in the United States caught on everywhere, especially on the West Coast, which was beginning to show a good deal of character. Pop held the mirror up to everyday America: mass-media advertising, movies and comic strips, the theatrical setting of the supermarkets, big-city life in all its anonymity from parties to suicide, and above all the personal cult vowed to Youth and Beauty and embodied in the synthetic smile of the idol called "The Star" (Andy Warhol, color-plate 43).

Connected with reality Pop art may have been, but it was certainly not the same as realism. It proposed instead an emblematic reality of signs and signals, created new symbols and fetishes for the Age of Consumers, combined real likenesses with a dream reality, and let reality turn into legends that had as little to do with real life as the Pop world of illusions has to do with the world you and I live in. As style it was an aesthetic and ideological position that worked out differently from one artist to the next. Because of his pictorial montages—"Combine Paintings," he called them—Robert Rauschenberg, was at the start dubbed a neo-Dadaist. True, he combined real objects with painting to make a new identity, but the comparison does not really stand up. In Dada, reality was meant to reveal its artistic value; with Rauschenberg art makes its claim to being itself reality as synthesis of fact and fancy, of real things and real concepts. By dispensing with a unified viewing point, Rauschenberg's works unleash a flood of ever changing impressions, a staccato of figurations one after the other, on top of the other, all of them having to do with our current times (colorplate 42). When Roy Lichtenstein seems merely to be making a meticulous copy of an enlarged screenprint of a picture by Picasso, the end product is no replica of the original but a picture on its own (color-plate 44). Larry Rivers' variations and alienations of old masters, on the other hand, still come across as classical painting, their confrontation with everyday things notwithstanding (fig. 21). Andy Warhol's most celebrated work, *Marilyn* (colorplate 43), is more than a photographically true translation of a photograph of a face into a picture. What we get from it instead is a stereotyped, alienated, morbid association, and technically the painting gives the effect of a simulated, reproducible, anonymous color

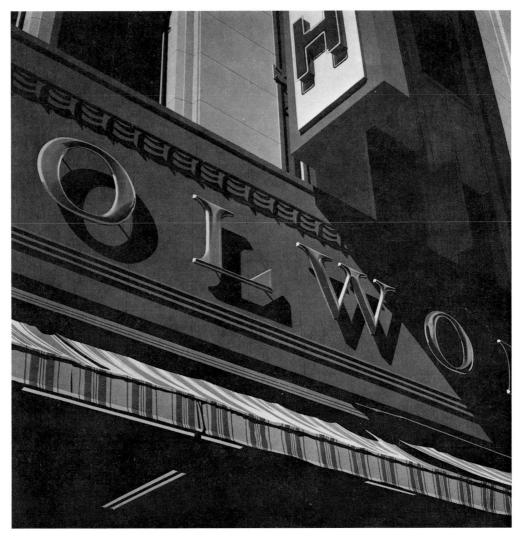

23. Robert Cottingham (b. 1935). *Woolworth's*. 1970. Oil on canvas,
78 × 78″ (198 × 198 cm). Collection Mr. and Mrs. Edward Bianci

print. With Richard Lindner, an American of German origin, violence and
eroticism are decisive accents in life for which he devised pictorial meta-
phors so insightful as to arouse anxiety (colorplate 45).

Precisely because Pop art was not actually and ultimately identical
with realism, another realistic type of painting could grow up alongside it
with which it has many points of contact. The realism of the 1960s and
'70s wears innumerable guises, each with its distinctive name. It covers the
world of visual phenomena in the whole wide range from reproduction

to manipulated counterfeit of the truly real: "The picture," explains Robert Cottingham, "is the new reality."

A major part of the most recent development calls photographic realism into question. Its point of departure is not reality itself but its photographic image, which in any event is not treated as a sacrosanct document but is reworked so extensively, and thereby so alienated, as to make us see yet another end product of a subjective process in which reality is observed and "rendered" (Gerhard Richter, colorplate 49). Fuzzy borders, fluctuations in sharpness, uniform values in all parts of the picture (impossible in a photograph), alteration of the pictorial space by shifts in viewing and vanishing points, a deliberate synthesis between what the camera lens captures and what the eye perceives have become criteria for a kind of photorealistic painting that actually ends up having less in common with photography, not more. This is because the creative utilization of these criteria both cites reality and throws it into question, stands for cool anonymity and surreal enigmatic implications arising from the

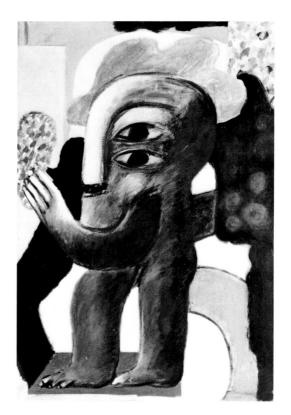

24. Horst Antes (b. 1936). *Green Figure*. 1963. Tempera and oil on canvas, 51 ³/₈ × 35 ¹/₂″ (130.5 × 90 cm). Kunstmuseum Sprengel Collection, Hannover

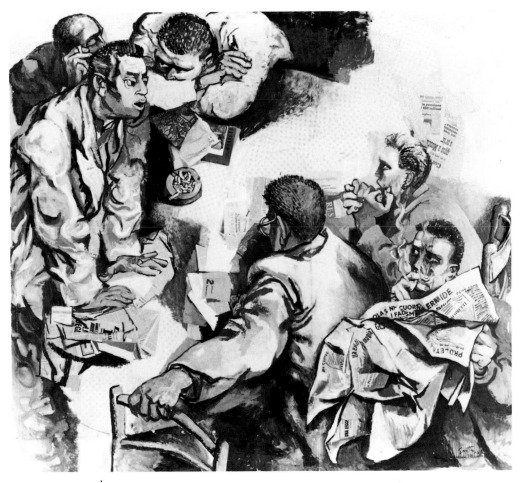

25. Renato Guttuso (b. 1922). *The Discussion*. 1959–60. Tempera, oil, and mixed mediums on canvas, 86 ⁵/₈ × 97 ⁵/₈″ (220 × 248 cm). The Tate Gallery, London

oversharp manner and directness of imaging (Richard Estes, colorplate 47; Chuck Close, colorplate 48). The subjects are almost always trivial, commonplace, trite. The artist's personal hand is as little in evidence as the material he paints with, from which in fact he asks nothing more than that it serve for putting his image on the surface with painful meticulousness. The reality that comes out of all this is every bit as synthetic as that of the colored picture postcards, color photos, or posters that are imitated or manipulated. Ultimately the result is no more than a monumental citation of concrete objectivity or pure formalism, turning upside down what the great American photographer Edward Steichen said: "The photograph has spared painting from having to be figurative."

This current has enjoyed no end of unquestioning popularity with the

general public, both because of the unique principle on which it deals with reality and because of the exceptional technical skill it obviously demands of the artist. Precisely the latter appears to give support to the ineradicable fallacy that art is strictly a matter of knowing and knowhow. Yet Photorealism has neither created a new way of seeing nor in any way altered our conception of reality.

The critical alternative to Pop art and Photorealism, which can only be touched on here, is Socialist Realism. Against the political background of our time, that movement has taken on importance and has also brought Eastern European artists back on the scene. Now as in the past its effect and influence have been limited less by the fact that it is not free of the conventional virtuosity of earlier epochs (very recent painting in particular has ultimately depended much on virtuoso technique) than by the ineluctable handicap that its reality is ideological and therefore a matter of conviction. Even its unarguable character as a political or moral rallying call cannot, with very few exceptions, disguise an all too evident anemia when it comes to artistic quality (Renato Guttuso, fig. 25).

What has been said here, then, suggests what the frontiers of painting may be but does not stake them out. From where we stand today we can scarcely say if present-day art has reached its peak or when some basic change is likely to occur. Whether we accept or reject the art of our time does not make it either better or worse. But as long as art asks questions and calls values into question it seems to me to offer a legitimate way for us to find and take up positions in our labyrinthine present, even if the answers are not always forthcoming.

COLORPLATES

Colorplate 1

ROBERTO MATTA ECHAURREN (b. 1912)
The Taste of Apocalypse, 1957–58
Oil on canvas, 44 $^1/_2$ × 57″ (113 × 144.8 cm)
Private collection

This painting perfectly exemplifies the way one current of American postwar painting grew out of European Surrealism. Matta, a native Chilean, became familiar with that movement in 1939 in New York, thanks to the European refugees gathered there. A trip to Mexico two years later acquainted him with the demonic world of early Mexican pictographs as well. But only with the personal shock resulting from the explosion of the first atom bomb did those components merge to bring about a real shift in the orientation of his art. If, as he has said, until then he had only looked within himself, thenceforth he was resolved to face up to the menace his own time represented, to what he saw as a fearful crisis in society.

The decision resulted in pictorial visions of truly apocalyptic dramatic potency. In the indefinable depth of his pictorial spaces—representing something like a dark cosmos—anthropomorphic mechanical devices and fantastic creatures born of technological myth disport themselves with an extravagant and demonic play of gesture. The human being is shut out of this sinister world of machine-spawned creatures that the artist seems to observe with a frighteningly cold detachment. There is no humanity in these odd forms that whip about in settings suggesting some science-fiction doomsday and rampant nightmares of technology. One cannot doubt that such pictures give vent to a deep anxiety over a future out of human control. But the new myth that Matta reveals in pictures like this is no fable. It is still bound up inextricably with our present reality, and for that reason Matta's works, decades later, continue to be shockingly up-to-date.

Colorplate 2

ARSHILE GORKY (1904–48)
The Betrothal II, 1947
Oil on canvas, 50 $^3/_4$ × 38″ (128.9 × 96.5 cm)
Whitney Museum of American Art, New York

During World War II the New York art scene took its tone from a group of European Surrealists and from a few younger Americans who transformed that movement's ideas into personal variants which became the bases for the flowering of American painting after 1945. Among those adventurous disciples was Arshile Gorky, born Vosdanik Adoian in Armenia, who had emigrated to the United States at the age of fifteen and received all his training there. For him, even more than the European influence, it was the stimulating ideas of his friend Matta (colorplate 1) that set the foundation for a stubbornly individualistic style with a pronounced penchant for the metaphysical, for the dream-like and mythical atmosphere and lyrical approach exemplified in this *Betrothal*. Spontaneous as it appears, the picture by no means sprang full-blown from the artist's mind but was preceded by a series of painstaking studies and only slowly took its definitive form. Free biomorphic figurations seem to have emerged on their own out of the soft paint surface covering the canvas. They fill the pictorial field with an utterly personal mythology behind which lurks the poetic reality of the dream. A very mobile, almost tentative brushwork pins down the mythical symbols and transforms them into a vegetation of feelings one senses as erotic, tender, or anxious. True, fragments here and there are easily deciphered as figurative, but this is not one of those pictures where something representational is transformed or concealed. Instead, anything figurative is heightened into a metaphor and so takes on new and different meanings. Gorky invented and developed a personal arsenal of communicatory signs and pictorial equivalents for a world of subjective notions that could never have been expressed through recognizable objective forms: thus painting as a means of communicating the deeper zones of mind and spirit.

38

WILLEM DE KOONING (b. 1904)
Yellow River, 1958

Oil on canvas, 62 $^1/_2$ × 49 $^1/_2$" (158.8 × 125.7 cm)
Private collection, New York

Born in Holland and resident in the United States since 1926, De Kooning was one of the prime movers of postwar American painting toward the first high point in Abstract Expressionism. Until about 1955 his art was still characterized by essentially figurative conceptions. *Yellow River*, however, is a pure abstract play of dramatically activated and colliding forces, a picture surface transformed into a field of explosive discharges of coloristic and painterly energy. The general goal and direction of the time is clear here: painting shakes off the control of a guiding intellect; colors flood over the canvas with apocalyptic urgency; the stormy gesturality of a hectically intensified handwriting makes the act of painting seem something like an eruptive outburst of long-dammed-up forces. The painter acts as the instrument of unleashed powers which are directed only from, and by, the subconscious, and which can only be expressed through the most violent use of the brush: a state of demiurgic intoxication contemptuous of all classical notions of painting and explainable only as the unconditional self-expression of a creative personality. To paint in the 1950s meant to express directly and immediately all the intensity of living; art was the name of a chaotic and anarchic field of absolute freedom serving only its own ends. The whole point of existence, Robert Motherwell admitted in retrospect, seemed to lie in running counter to all established order. But painters who violate the old order set up, at the same time, a new order, unconfined freedom results in new ethical restraints, and—as this picture reveals—what looks to be arbitrary and unbridled denotes in fact a powerful continuity of unbroken vitality. These are home truths, but they were not applied in the 1950s to those we now respect as the founding fathers of postwar art, who in the years when they were at their creative peak thought themselves unwanted and misunderstood by the society to which they belonged.

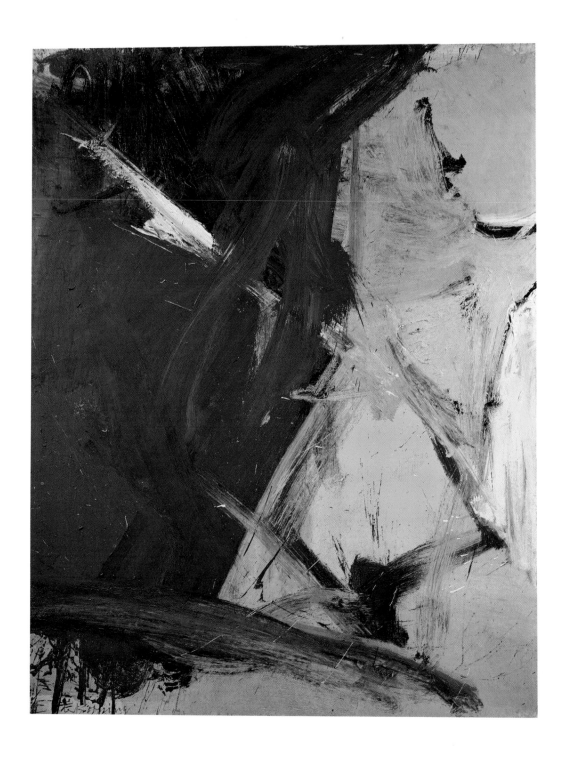

Colorplate 4

ROBERT MOTHERWELL (b. 1915)
Elegy for the Spanish Republic, No. 34, 1953–54
Oil on canvas, 80 × 100″ (203.3 × 254 cm)
Albright-Knox Art Gallery, Buffalo, New York. Gift of Seymour H. Knox

The white surface of the canvas is disrupted by a few monumental, almost ponderously ungainly shapes. Contrasting harshly with the ground, the shapes take on a somberly concentrated force made harsher still by the absence of any shading or transition. The white ground makes something like a faint light which, blocked by the heavy beamwork, seems to seek its way forward laboriously. Yet nothing in this painting suggests an experiment in surface ornament or geometric shapes. Instead there is an immediate feeling of deeply expressive painting imbued with somber drama. The restlessly taut handwriting ends up in the compactness of closed forms yet brings to the composition a note of vibrating disquietude. What we sense in abstract form is confirmed by the title of the picture, which alludes to a tragic chapter in European history before World War II that few painters—aside from Picasso in *Guernica*—chose to commemorate. Motherwell, however, unlike Picasso, did not denounce the brutality of the event by training a lightning-flash of horror on an anguished scream. Instead his work conveys a muffled dejection, grief, consternation: feelings that somehow come through to us entirely apart from any literary content or connection, through the inherent expressive capacity of simple pictorial means. The theme occupied Motherwell for over a decade, and it led him to introduce into the new and still developing language of American Abstract Expressionism a new, broader, meaningful dimension affecting both form and content. In the terseness of their language of signs, the sheer power of their symbolic message, and the depth of human feeling they communicate, Motherwell's works on this theme occupy a unique place in postwar American painting.

Colorplate 5

JACKSON POLLOCK (1912–56)
Number 3, 1949

Oil and aluminum paint on canvas mounted on fiberboard,
62 × 37 ¹/₈″ (157.5 × 94.3 cm)
The Hirshhorn Museum and Sculpture Garden, Smithsonian
Institution, Washington, D.C.

A whirling festoon of intertangling skeins of paint transforms the
surface into a plane of dynamic tensions, heightened vitality, rhythmic
pulsations. There is neither space nor form in the classical sense, nei-
ther content susceptible to literary interpretation nor even some sort of
definable objective theme. Painting has become an abstract script on an
unbounded field one takes to be extensible on all sides. It has become
pure action, an action that tells us something of the psychological state
of the artist when he put paint on canvas. We are looking at the end
product of a process of expression which has recorded, as in a seismo-
graph's tracings of the earth's tremors and upheavals, the evidence of
motoristic forces, psychological impulses, and feelings transposed into
dynamic movement. The artist no longer sits comfortably before an
easel but stands and moves around the canvas, which is considerably
larger than anything he could set up on an easel, spread out on the floor.
Paint is not applied in the usual way, nor is it the usual stuff squeezed
from neatly labeled tubes. Paints, varnishes, emulsions all have to be as
liquid as possible to be used in the dripping process with which, even
before the Abstract Expressionists, Hans Hofmann had experimented.
Colors are dripped from brush or palette knife, or run out through a
hole in a tin the artist swings across the canvas laid on the floor. Simple
means, but the traces they leave behind make a record of the utmost
immediacy, surpassing everything even the most expressionist art had
dared. "Up" and "down" no longer mean anything. The new cosmos
has nothing to do with perspective; it is viewed and viewable from all
sides. A painting is a slice of the infinite. In short, there is a new idea of
what a picture is, one which bears a relationship to the image of the
world devised by the physicists of our time. In the realist sense, such
pictures are "informal" (a neologism that covers a multitude of mean-
ings): not a structured image but the mark left by a taut moment of
existence, an event—a happening—between chaos and order, between
expression and contemplation. The act of painting becomes an activity
of existential significance.

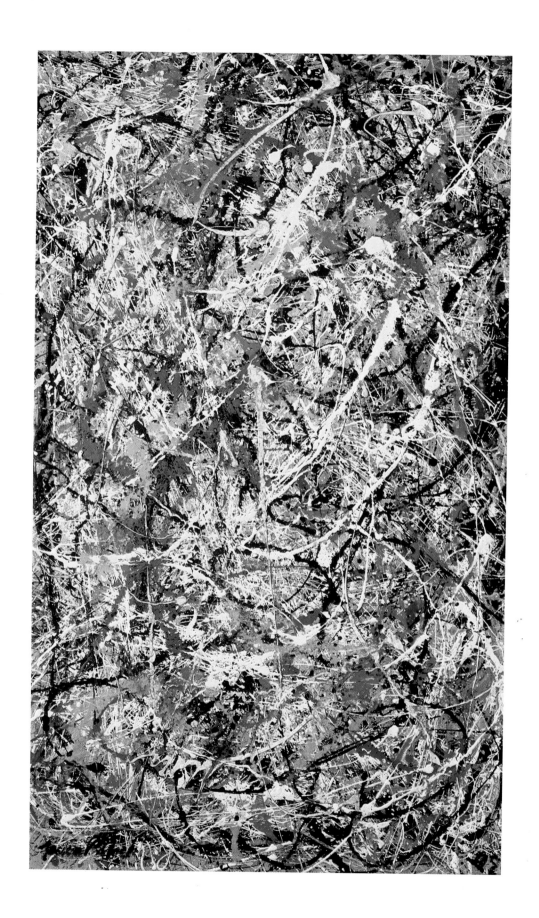

Colorplate 6

FRANZ KLINE (1910–62)
Painting No. 7, 1952
Oil on canvas, 57 ¹/₂ × 81 ³/₄″ (146 × 207.7 cm)
The Solomon R. Guggenheim Museum, New York

In 1952 the critic Harold Rosenberg coined the term "Action Painting" to describe the dominant movement in American art. The term was remarkably apt for an art in which the chief accent had been shifted from content to the free expressive gesture, to large simple forms of dramatic power and often somber expressivity, although it applied less fittingly to the more contemplative expressions of Rothko, Newman, and others. Among the major exponents of the former trend was Franz Kline, who, after more or less traditional beginnings, entered the New York scene around 1950 with large-format paintings in which heavy black splintery bars as solid as beams and girders stood out like powerful signs against light grounds. His broad, gestural movements, executed with an exceptional controlled power, often recall the pictorial character of Far Eastern writing and sometimes suggest a kind of spontaneously notated dynamic psychogram. Color in its traditional use as a vehicle of expression and sensations was largely expunged in Kline's work, essentially because, in the large format in which he worked, the magnified tension between a menacing black and a cold and often broken-up white constituted in itself the content and expression of the picture.

If Kline's paintings, for all their emphasis on the expressive sign, remain notations of inner tensions, their pictorial content involves something more than a dramatically intensified handwriting. Comparing them with Pollock's sensitive tracks of color, another side of expressive painterly action becomes evident: the effort to unite form and space convincingly. The girders of paint rise like a powerful barrier before the canvas, whose emptiness and lack of formal boundaries imply a cosmic character. Between the unequivocally defined foreground and the indeterminable depth are built up those tensions which constitute the basic pictorial theme: the position of man with regard to the cosmos and its forces.

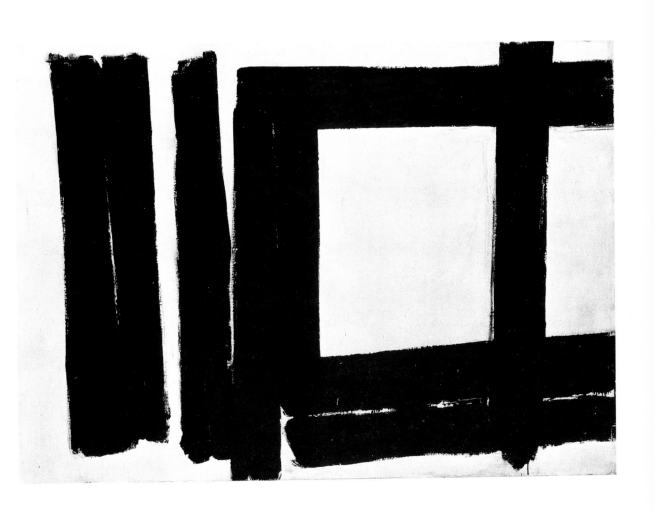

MARK ROTHKO (1903–70)
Number 207 (Red over Dark Blue on Dark Gray), 1961

Oil on canvas, 92 $^3/_4$ × 81 $^1/_8$″ (235.6 × 206.1 cm)
University Art Museum, University of California, Berkeley, California

Born in Russia and brought to the United States at the age of ten, Mark Rothko, like so many artists of his generation, set out on his artistic path under European as well as American-regionalist influences. It was not until around 1949 that he gave up the last vestiges of Surreal figuration and began to paint pictures which, in their incorporeal, insubstantial use of color and their infinite repose, were distinguished from the dramatic gesturality of Action Painting as currently practiced by artists such as Pollock, De Kooning, and Motherwell. Rothko's paintings, with their fields of pure color emerging from an undefined monochromatic ground, were very different. These "walls" permeated with a dark light have nothing in common with the traditional notion of a picture. Their power of suggestion resides entirely in the heightened expressive capacity of color as such. Even complementary color contrasts—the dramatic effects of red against green, blue against orange, yellow against violet that appealed so much to the Expressionists—were largely ruled out. Instead, Rothko usually opted for tones that would echo one another and for passages between neighboring color values—red to brown, blue to gray, yellow to orange—which, spread across his frequently very large canvases, would combine into unprecedented harmonies. The modulation of these sensitive color harmonies ultimately gives rise to a uniform and unifying light of such spiritual character as to lend these paintings something of the timelessness and nobility of ancient myth. But using color in this manner also does away with the traditional compositional confines. The picture surface seems a moment isolated out of infinity, broadening out into the unlimited; the spatial effect of the colors lets the painting breathe and transforms it into an imaginary space. If the preference for oblong or square areas of color might seem to suggest something inflexibly geometrical, this is effectively forestalled by Rothko's extreme sensitivity in the use of paint. The color areas interpenetrate in a most subtle manner, with fluid boundaries that cloud over and sink back into the spatially indeterminate matrix, taking shape and fading away.

Although this sort of painting often appears to take on the character of a magical process of evocation, it is nonetheless thoroughly within the spirit of its time. Color becomes identified with expression and sensibility, striving to communicate the inexpressible and transforming the picture into a field of meditation, a modern icon in which, somehow, old Eastern European modes of viewing and feeling still live.

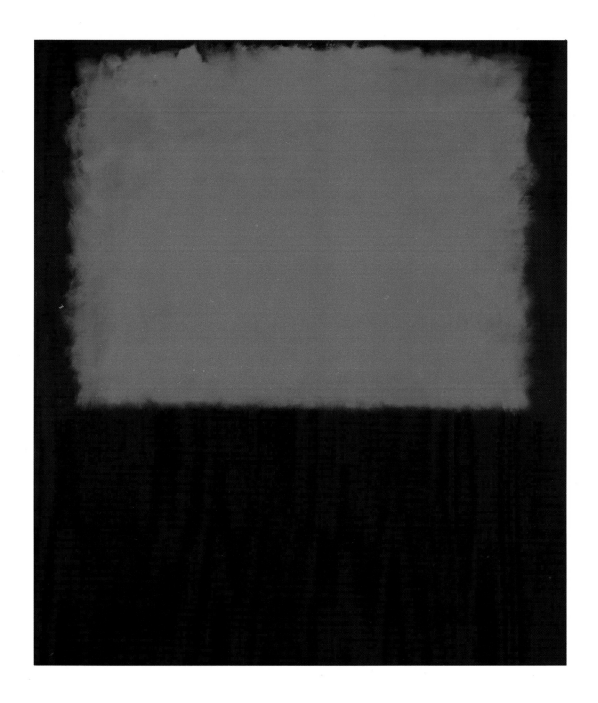

49

Colorplate 8

BARNETT NEWMAN (1905–70)
The Word, 1954

Oil on canvas, 90 × 70″ (228.6 × 177.8 cm)
Collection Mr. and Mrs. S. I. Newhouse, Jr., New York

In 1948 Barnett Newman began a new series of paintings in which he rapidly sloughed off European Surrealist influences. The ensuing works document yet another new approach to abstraction. A different process of apprehension is demanded by the unusually large formats that exceed the normal field of vision, the open color-forms that make the picture seem part of something unlimited, and the close viewing distance the artist himself called for. Newman's color fields are always monochromatic, with a vertical strip or strips in other colors that give rhythmic accents to the picture ground without, however, evoking anything we think of as "painterly." Though ostensibly geometric, his approach does not give in to the compulsory rigor that governs concrete art, nor, apparently, does it even toy with such ideas. Conventional pictorial themes are replaced by what can be called a "new content," something Newman had been striving after for a long time before his breakthrough in 1948.

If the qualities we have described so far seem contradictory, they nonetheless account for what is both elemental and archetypal in Newman's work. In *The Word* the canvas is divided vertically by four strips of different color, intensity, and width. It is not only because the severe black is heavier and more extensive that it sets the character of the composition. It brings into play a certain transcendence alluded to also in the title. As Newman explains, "I tried to make the title a metaphor that describes my feeling when I did the painting." Thus, like others at the time, he considered painting to be an expression of spiritual experiences and the picture to be the basis for meditation, a timeless metaphor liberated from those "obstacles of memory" that weighed down the European mode of thought. The Word: the concept is of enormous breadth and at the same time finality. Dark and light, tension and repose, contrast and harmony, passion and coolness, biblical allusion and mythology, all come together to create a new identity for the picture: the infinite realized in the rigorous rhythm of absolute color.

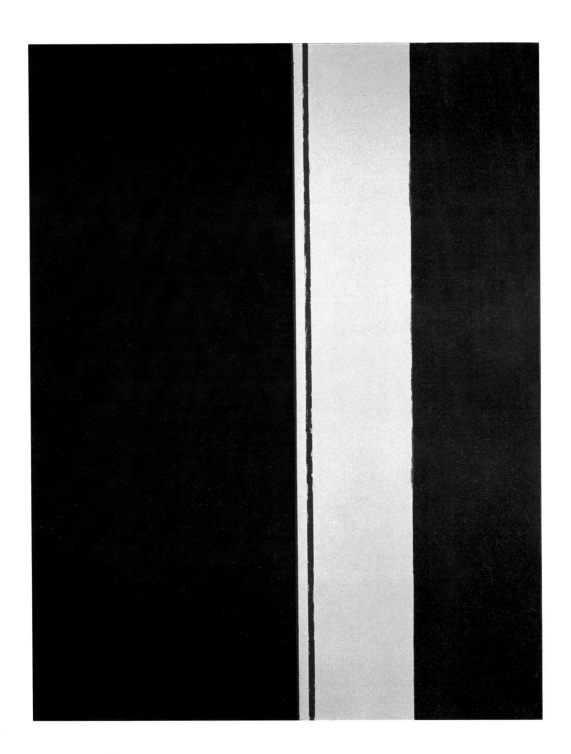

Colorplate 9

CLYFFORD STILL (1904–80)
Painting, 1951
Oil on canvas, 94 × 82″ (238.8 × 208.3 cm)
The Museum of Modern Art, New York. Blanchette Rockefeller Fund

Barnett Newman, Mark Rothko, and Clyfford Still were not only of the same generation; they also agreed in rejecting the methods and aims of the more violently expressive and gestural wing of Abstract Expressionists. The works of Still, a native of the West Coast who did not move to New York until 1950, evince a relationship to color, a conception of its pictorial value and expressive capacity, quite distinct from that of Pollock, De Kooning, and Kline, with their passionate desire for self-expression and involvement in the psychological meaning of their own handwriting in paint. Although Still's language has nothing to do with brute gesture, its impact is scarcely less intense, as one sees here.

An overpowering, almost menacing black seems to throw a barricade across the picture. Looked at more closely it no longer appears as something on the surface, but as an intensely worked area which has set off a vibration rooted in the modulation of a single tone. All the colors juxtaposed to the black appear light, whether the muted blues and violets at the left or the emphatically contrasting colors of a more active scale at the right. Thanks to these subsidiary colors the black acquires a tendency to project, to "jump out" at the viewer. Ultimately it appears to expand beyond the confines of the canvas, so that the picture seems excerpted from a space without end; the compositional boundary lines familiar in Western art for so many centuries have given way to an undefined pictorial space. The picture *is*. It represents nothing but itself and the artist's intentions, though at least in the latter respect it remains within the tradition of an art of expression. Clyfford Still opened up an approach which today is reckoned as a step toward the New Abstraction, an art uninfluenced by either past or present or, least of all, by any historical relationship with European art, "so that a direct, immediate, and truly free vision could be achieved."

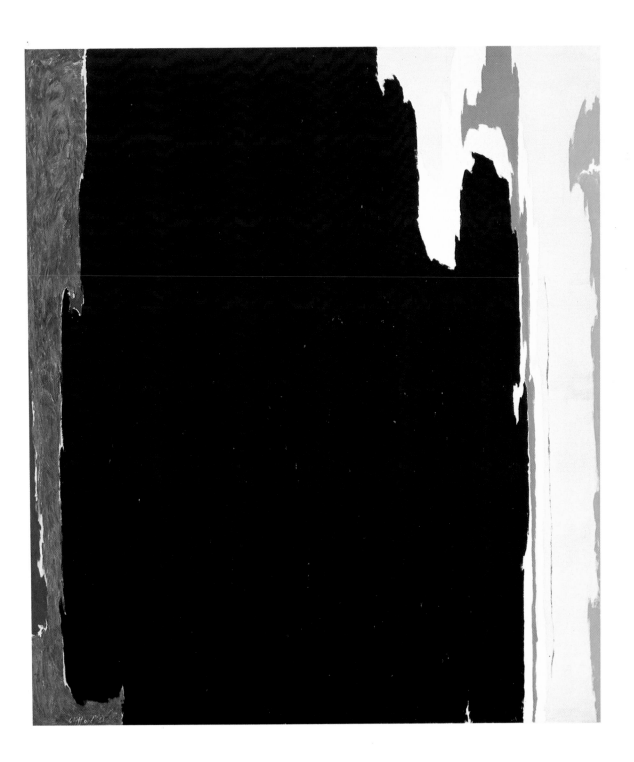

Colorplate 10

SAM FRANCIS
Over Yellow II, 1958–60
Oil on canvas, 14′ 10 ³/₄″ × 8′ 9 ¹/₈″ (454 × 267 cm)
Moderna Museet, Stockholm

The title itself immediately makes clear that this painting involves a serious effort to use color, without representing any object or anecdote, so that it seeks and finds its own form. Modulations of full-strength colors cover the canvas in multiple shapes against the basic resonance of the underlying white as an equal partner. The color-shapes are laid on with very liquid paint. At the edges the paint dribbles down—bleeds off—in a highly sensitive free play. The surface opens into a richly differentiated picture-space in which the effects of depth are intimately connected with the nuances of the shapes themselves. Thus, a powerfully blazing red pushes forward, deep blues make cooler contrasts to the red, a warm cloudy yellow mediates between them, and harmonies are created by mixed colors and overlaid coats of paint. The experience of the real world is transformed into something musical through the counterpoint of colors.

This profoundly painterly approach, like Clyfford Still's, is surely to be identified as deriving from the outlook and landscape of America's West Coast. The way Francis carries over his spontaneity into large forms, the way too in which the old distinction between figure and ground is canceled out in favor of Jackson Pollock's "all-over" format, define this approach as contemporary with Abstract Expressionism. Whatever its differences, the originality and highly individualistic achievement of this art were typical of the new American painting of the 1950s that would quickly make its way in Europe as well, not insignificantly through the example of Sam Francis, who settled in Paris as early as 1950 and whose very personal style came to be much appreciated by like-minded French painters.

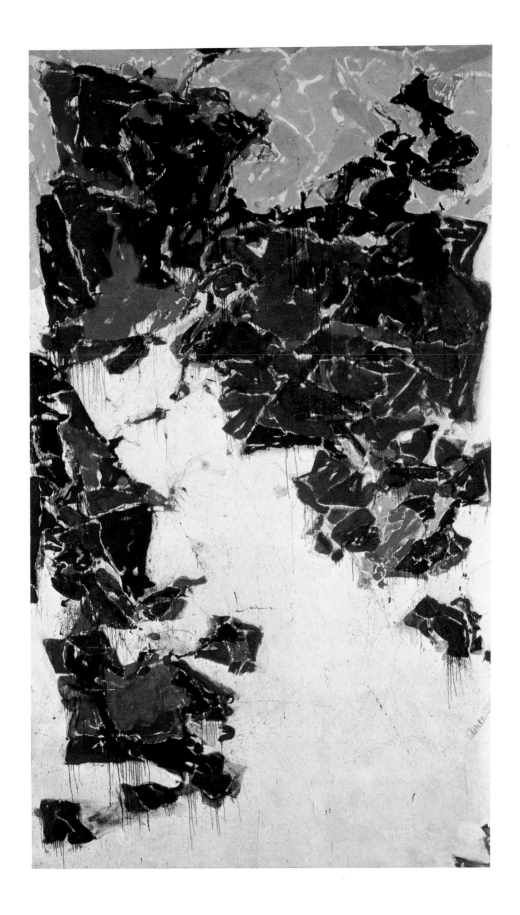

MARK TOBEY (1890–1976)
Plane of Poverty, 1960
Oil on canvas, 73 × 44 $^1/_8$″ (186 × 112 cm)
Kunstsammlung Nordrhein-Westfalen, Düsseldorf

The surface of the picture is covered with a delicate filigree-like network
of calligraphic lines. One is aware of vibrating movement and senses the
canvas not as plane surface but as space of indefinable depth whose
character derives entirely from the medium. Reminiscence of anything
we have ever seen is obviously neither attempted nor, as in many other
abstract works, does it occur through tricks of chance. Not even color
has value in itself, and its reverberation simply underscores the strange
inner stillness one senses despite all the movement. On the other hand,
the linear tracks seem to be an indecipherable script, in essence and
manner much like the pictographic signs of Far Eastern calligraphy,
without being in any way an imitation of them. Through the study
of Oriental thought and calligraphy, certain artists of the American
West Coast, especially Tobey from Washington, found their way to a
very personal style in which the picture functions as a nonverbal com-
munication of states and sensations that have to do with purely human
feelings. After his initial study of Bahai thought and his trips to China
and Japan, Tobey drew closer to Zen Buddhism and attempted to develop
pictorial signs for communicating his own essentially Western way of
feeling and seeing. His first works, done in the 1930s, were recognized
after the war as, in their own way, paralleling the expressive processes
by which painters like Pollock (colorplate 5) or Hartung (colorplate 16)
were allowing emotional excitement to enter the picture directly, to *be*
the picture. Tobey's art, however, is distinctively and purely meditative.
It aspires to a harmonious accord between inward and outward phenom-
ena, to a concord of individual and world that has neither place nor
need for drastic self-expression or dramatic gesture. Experience gained
through absorption in the inner self, rather than action, is what gives
Tobey's paintings their unmistakable delicate resonance.

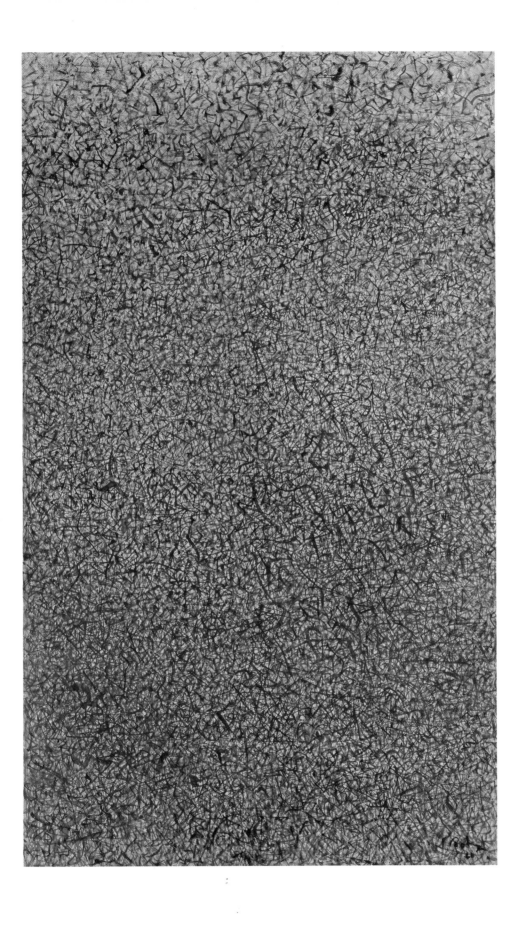

Colorplate 12

CY TWOMBLY (b. 1928)
Discourse on Commodus IV, 1963
Oil, crayon, chalk, and pencil on canvas,
80 $\frac{1}{4}$ × 52 $\frac{3}{4}$" (203.8 × 134 cm)
Private collection

Cy Twombly's art eludes neat labels and stylistic pigeonholes. Broadly speaking, it has roots in Abstract Expressionism: in the work of Motherwell and Kline, who were his teachers at Black Mountain College; and in the "all-over" principle of Pollock, from which a picture such as this still proceeds. Its margins in no way mark off compositional boundaries, and the entire picture must be thought of as an excerpt from a larger continuum. Here and there on the light-colored canvas there are seemingly unrelated markings, not painted in any "normal" fashion but laid on right from the tube, without brush, and whipped up with the bare hands into tangled, almost jumbled shapes of the highest expressivity, as if in the process of taking form out of the unformed and formless. Graphite lines run around isolated shapes, words are scribbled in and sometimes scratched out again. There is no central compositional focus, yet this is itself a principle of the picture. It requires a way of seeing that defies an analytic approach, with its concentration on individual phenomena, and comes closer to the kind of perception that children, for a while, retain: something like a bird's-eye view of decentralized events, a continuous shift from space to detail, from detail to space.

After settling in Rome in 1957, Twombly often turned to themes from classical antiquity. This is one of nine pictures having to do with Marcus Aurelius' son, the Roman emperor Commodus, who left a bloody track in the pages of history, signified here perhaps by the slashes of red. A confused tension weighs on the canvas, a profound unrest and inner strife tell us that the picture is to be read as a psychological state—harsh, brutal, ominous—rooted in history and held at an aesthetic distance. Traditional interpretations result in absurdity. One has to learn to read and make sense of pictorial signs concealing the creative process itself, a process to be understood as the notation of the artist's dialogue with his own inner world. Those signs neither function in terms of painting itself nor refer to specific situations. What they signify is most likely to reveal itself to a viewer who intuits and shares something of the artist's highly personal approach.

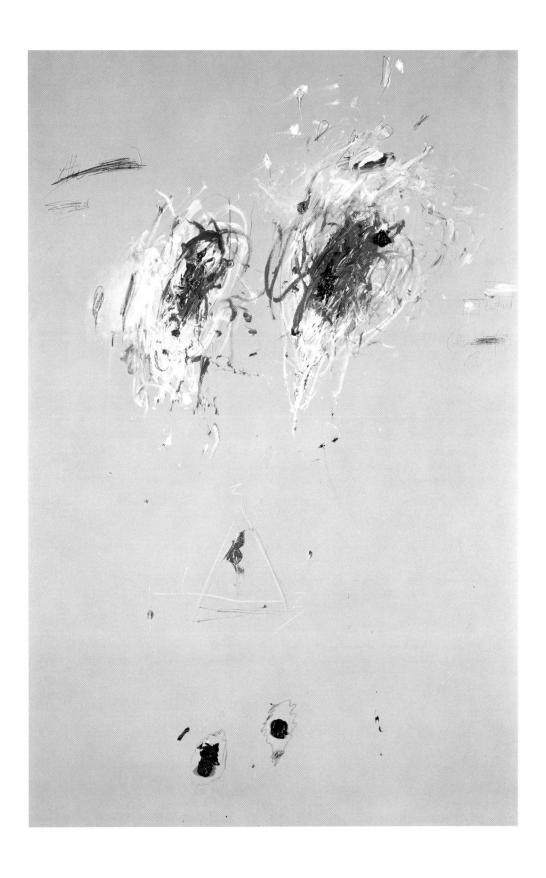

Colorplate 13

ALFRED MANESSIER (b. 1911)
Crown of Thorns, 1951
Oil on linen-backed paper, 22 $^7/_8$ × 19 $^1/_8$" (58 × 48.5 cm)
Folkwang Museum, Essen

Since the first phase of abstract art in Europe began in about 1910, it has been clear that experience and feeling can be communicated without the aid of any objective motif or subject, purely through the pictorial means of color and form, which conjure up a new, higher reality more pungently than any real depiction and signify the inner essence of a thing. If at first glance Manessier's *Crown of Thorns* seems totally non-objective, one quickly senses the association with the spiritual nature of color in medieval stained-glass windows. Here too the colors take on a glow from the light that falls on them. Their luminosity comes through even the dark shapes in the foreground, which act as a kind of blocking grille powerfully suggesting a circling crown of thorns with all that it recalls of the instruments of the Passion. These shapes embody the theme in visual form, serving as a symbol of suffering, a metaphor for the events they symbolize. Yet all connection with reality is banished from the colors themselves, whose quiet but powerful harmony is profoundly spiritual in its effect. In the colors, which cover the picture ground like a mosaic and give rise to marked spatial tensions, one can read the commitment of an artist who is also a devout believer.

But quite aside from their symbolic function, color, form, and light continue to enjoy a full measure of autonomy which, as one would expect in the French tradition, gives Manessier's work a high aesthetic rank in abstraction as well. That a painting which is so evidently "beautiful" should also be able to express a spiritual message and convey religious feeling accounts for the artist's special place within postwar abstractionist currents.

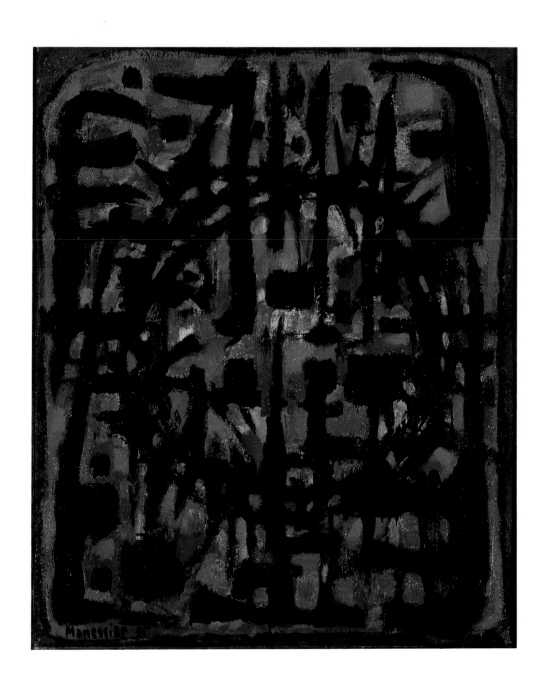

Colorplate 14

PIERRE SOULAGES (b. 1919)
Painting 14 March 1955
Oil on canvas, 76 $^3/_4$ × 51 $^1/_8''$ (195 × 130 cm)
Folkwang Museum, Essen

The essence of the art of another major master of the postwar École de Paris, Pierre Soulages, resides not in the expressive force of a spontaneous painterly gesture, as in the work of Hans Hartung (colorplate 16), but in the picture as solemn icon. The vehement action of the painter's brush has made way for a powerful system of buttresses composed of heavy dark beams. A large and solemn construction binds color and form into a solid framework of paint laid on with various sizes of palette knives rather than brushes. The balanced composition of sweeping black beams stands like an ominous symbol before an open ground lost in indefinable depths. A magical light lends brightness to a few parts of the picture. It pushes forward from behind the dark areas to arouse strong spatial tensions and a visionary feeling, and is refracted back again before breaking completely through the rigor of the tectonic composition.

Here we confront the counterpart of the German will to expression; a strong painterly vitality submits to rigorous organization, and the artistic goal is not self-expression but the fully developed, aesthetically effective picture. As much as the picture belongs to a particular moment and situation, in its formal perfection and painterly brilliance it proves itself part of a specifically French tradition. There is, nonetheless, an archaic power in the image, a somber passion, and the reaction it arouses in the viewer is not only visual but in equal measure spiritual. Though monumental in character, the image is also a highly sensitive play of light and space, arousing associations with primal figurations and processes of growth to which the veiled and even occult light brings a mystical luster.

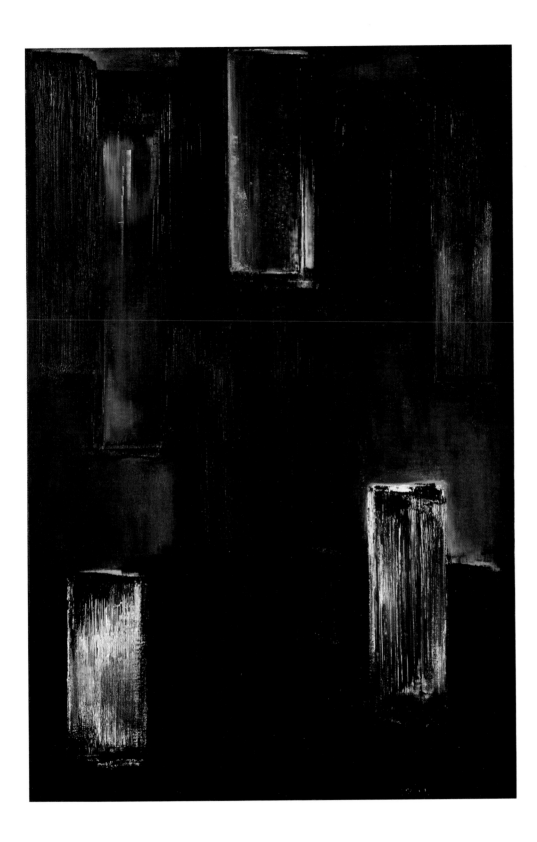

Colorplate 15

WOLS (A.O. WOLFGANG SCHULZE; 1913–51)
The Windmill, 1951

Oil on canvas, 28 ³/₄ × 23 ⁵/₈″ (73 × 60 cm)
Westfälisches Landesmuseum für Kunst und Kulturgeschichte, Münster

A dull-yellow ground is assaulted by nervous calligraphic tracks which look more like lacerations in the canvas than painting in any customary sense. Perspective is abolished; a multifocal space, no longer bound to any particular viewing point, results from the optical experience of freely moving and intersecting lines, which seem to lie between the closed plane of the picture and the fragmented ground. If a windmill is depicted here, it is by little more than accident. The painting is, rather, the record of a man who has been in peril and pain and who has set down, as if in a dialogue with himself, tortured signs of what he has lived through and endured, the evidence of a threatened existence, of a bitter fate exposed to need, persecution, and exile from any and every homeland. What matters is only the handwriting of that experience unmediated by the slickness of a professional product. It is a seismographic tracing of the dire convulsions in a human existence, of a struggle that offers no way out, and of the man's imminent self-destruction. This rather than the virtually accidental subject matter constitutes what can still be called the "content" and the "message" of the work. Its ultimate effect is of intense subjectivity scarcely under the guidance of the intellect.

The initial impetus for Wols' art came from the Surrealism with which the young Berlin photographer and writer concerned himself in a rather marginal way during the 1930s in Paris. Not until 1946, after knowing war, flight, and internment, did he devote himself entirely to painting and drawing, producing works which are always in some way concerned with man's condition and fate. Such painting can be considered an extreme case, yet it soon proved itself part of the new international expressionist awareness represented by such artists as Pollock, Kline, Hartung, and Tobey, and had an immense and enduring impact on the exponents of Tachisme and Informal painting.

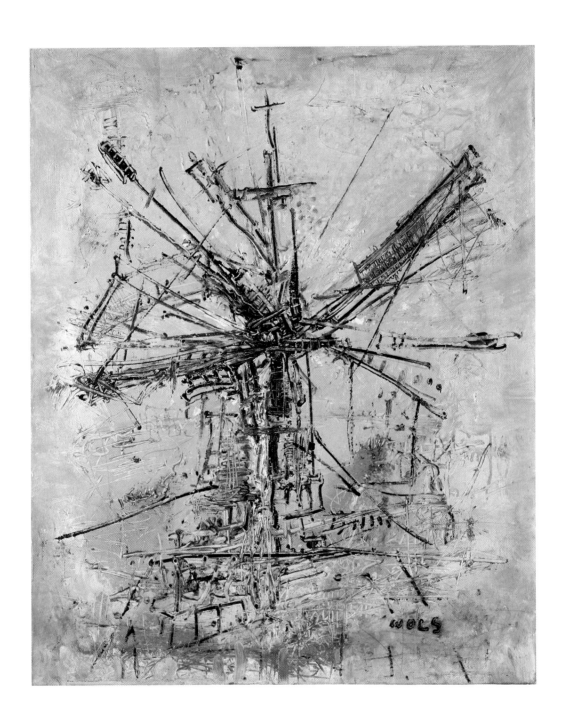

Colorplate 16

HANS HARTUNG (b. 1904)
Composition T 55–18, 1955
Oil on canvas, 64 × 43 $^1/_4''$ (162.5 × 110 cm)
Folkwang Museum, Essen

The brush has left the marks of a highly personal handwriting on a sensitively toned background; a bundle of strokes, varying in width, impulsively shoot up or down, fan out, come together again, make diagonal and vertical accents. Color as a value in itself plays scarcely any part, although a few brighter notes contrast, like vestiges of light, with the graphic formal scaffolding. "Psychological improvisation" is the term that has been applied to this kind of abstraction, which no longer involves pictorial content or theme in the customary sense but rather a spontaneous notation giving information about the psychological (or spiritual, if you wish) state of the artist. The picture becomes a psychographic imprint of a moment in the artist's life.

Hartung took quite early to exploiting pictorial means as direct notation of his inner experience. Influential in that approach were certain ideas developed by Wassily Kandinsky even before World War I. These had to do with the direct transposition of psychological states into color resonances, and what Kandinsky called for was an awareness of color and form as vehicles of expression and for a serious exploration of their communicative possibilities. After World War II such ideas offered a new point of departure for Abstract Expressionism on both sides of the Atlantic. It was natural that an artist like Hartung, with his roots in German art, should give preference to graphic rather than painterly elements, but in any event, essential as is the urge for expression in this approach, the aesthetic aspect is no less important. If an artist is not merely to give himself over to his inner impulses but, at the same time, is to find appropriate outward form—artistic form—for what he so urgently desires to communicate, he must command considerable skill as a painter and adhere to an unswerving artistic discipline. In the case of Hartung, his native expressionist tendencies were tempered by the tradition of France, where he has lived since the 1930s. Thus, as a major figure in the École de Paris, he has brought German and French elements into a convincing synthesis.

Colorplate 17

ERNST WILHELM NAY (1902–68)
Circle Sign, 1961
Oil on canvas, 78 $^3/_4$ × 47 $^1/_4''$ (200 × 120 cm)
Kunstsammlung Nordrhein-Westfalen, Düsseldorf

"Painting means forming the picture out of color," Ernst Wilhelm Nay once said, and no explanation more precisely pinpoints the character of his own work. In his paintings there is no question of subject or motif, content or expression, but only of color that no longer represents anything outside itself. The title of this work is simply an allusion to the basic formal theme (dominant in Nay's work from the mid-1950s), which absorbs into itself all other lines of movement, whether horizontal, vertical, or diagonal, without, however, disowning or ignoring them. The spontaneity and sheer force of the paint application make the disks whirl across the canvas in a furious rhythm, as if on the first day of cosmic creation, thus negating geometric rigor. Intense drama in the formation of shapes accompanies the extreme tensions among colors, which achieve a spatial value that almost violently opens up the surface, right down to the darkest depths. The sensuous fullness of a gleaming red bursts through the background like a volcanic eruption, creating contrasts or harmonies with other tones that may be lighter or darker but are no less intense. Color alone shapes and carries the picture and is its sole and inherent value. It gives rise, like chords and melodies in music, to a crescendo of breathtaking movement. Nay's use of color owes as much to the expressive sensibilities of German art as to Abstract Expressionism.

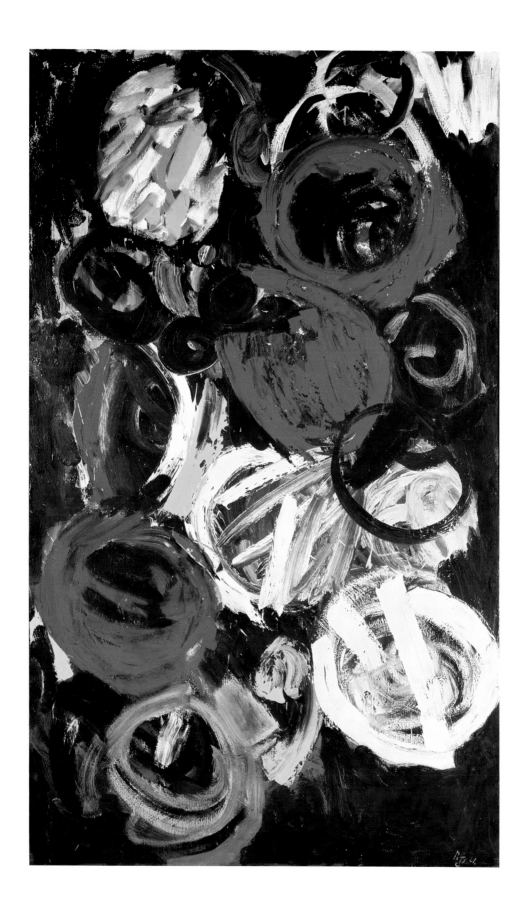

Colorplate 18

EMIL SCHUMACHER (b. 1912)
Telis, 1961
Oil on canvas, 39 $^3/_8$ × 31 $^1/_2$″ (100 × 80 cm)
Westfälisches Landesmuseum für Kunst und Kulturgeschichte, Münster

Emil Schumacher occupies a special place among the innumerable artists practicing a German approach to Abstract Expressionism since the 1950s. He is concerned not with giving visual expression to exacerbated emotions in a spontaneous frenzied action but, instead, with the picture as autonomous object, with its material, with the physical substance of colors rather than their expressive value. It is the creative process—if one can still use that traditional notion—that constitutes the sole and unique content of his pictures. The way the materials were used and misused causes our response to such works as both visual and tactile experiences. As a record of the artist's creative act—of resistances encountered and solutions worked out—the painting takes on the character of drama, of fatefulness, without recourse to any specific theme or pictorial motif. The titles of Schumacher's works confirm this. Freely invented verbal structures (though not always free of associations) are also created out of unformed material, and their sound and implications closely accompany the very special character of the pictures. Creation, with Schumacher, casts a wide net, embracing the brute struggle with material as well as a lyrical resonance. His pictures have been read as an effort to approximate the creative process of nature itself and as tense struggles between force and counterforce, between the artist and unformed matter. In the series of paintings represented here, the agitated surfaces are overlaid with severe black lines without a hint of calligraphic elegance. Set against a disrupted or quiet ground, these lines become metaphors for what is unsaid, signs for a pictorial thinking that, with rigorous logic, creates a new pictorial reality.

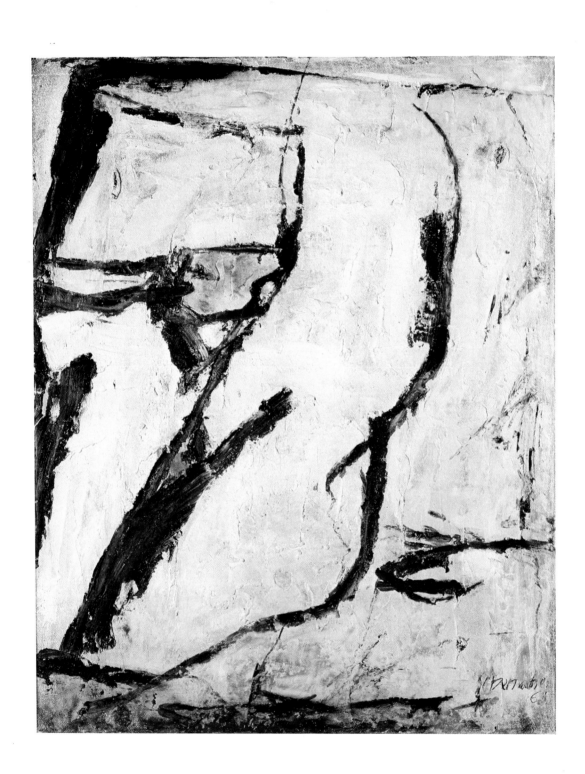

71

Colorplate 19

BERNARD SCHULTZE (b. 1915)
Tellurian Physiognomy, 1955
Oil on paper, 46 $^1/_8$ × 44 $^1/_2''$ (117 × 113 cm)
Folkwang Museum, Essen

The first impression is of chaos. The paint moves dynamically across the surface in whirlpools, its shapes clouding over and disintegrating, inter-penetrating, slipping away, losing their appearance only to form again in other shapes. Color is strong and artificial, yet possesses neither a pictorial value in itself nor an emotional expressive function such as we know from other works of Abstract Expressionism. Schultze's painting is not the self-expression of a creative personality but an analogy to Creation, a pictorial metaphor for the chaotic genesis and evolution of nature. Neither subject matter nor some particular emotional state is the decisive factor. The creative act takes place in and issues from the raw material of paint itself, out of which the picture surface grows layer by layer. It swells up, puckers, erupts into hills and mountains, lets whirling streams of color seek their way like rivers between the heights. Such works, with their subterranean reminiscences of the natural processes of evolution, perhaps have a parallel only in the realm of geology. Relief maps of the earth in the age when it took shape might have looked like this, a wild wasteland without order, yet plowed through with mighty forces and infused with life by an explosive dynamic. This tellurian physiognomy is the countenance of an earth in the making.

Over and beyond such analogies, these paintings also represent points of departure in the development of modern art. They are among the earliest "matter pictures" in which the surface becomes concretized as an independent object, as distinct from the illusionism of traditional painting. Schultze was one of the first German Tachistes, and his art clearly reflects the situation in that country as it was rejoining the international mainstream of contemporary art.

72

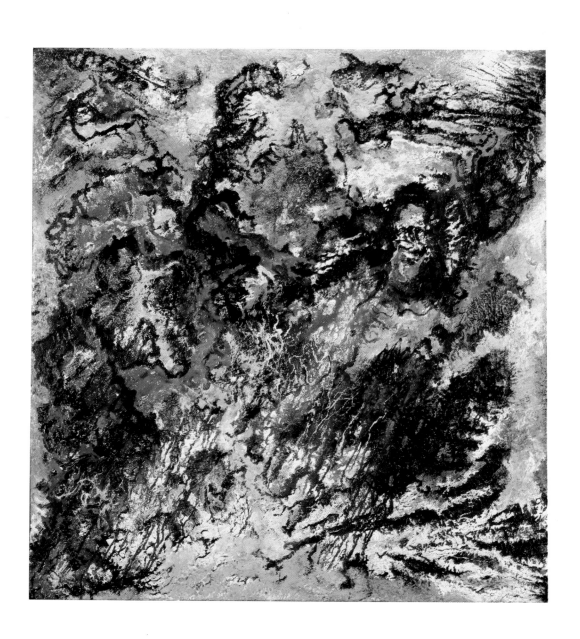

Colorplate 20

K. R. H. SONDERBORG (KURT HOFFMANN; b. 1923)
Paris, 34, Rue Boissonade 9.II.58 23.12–00.06 Uhr, 1958
Egg tempera over paper on canvas, 42 $^1/_2$ × 27 $^1/_2''$ (108 × 70 cm)
Galerie der Stadt Stuttgart

Speed is the theme of this painting, the driving force guiding its creation
as a chronicle of dynamic forces. The diagonals shooting upward give
the impression of point-blank acceleration, while small splintery kinetic
elements seem to scan the rhythm of that furious sweep. What is pri-
mary here is not the spontaneous reaction of psychological improvisa-
tion, nor any other sort of pictorial response to emotional stimuli,
though these are certainly conveyed. The essence of the picture lies
instead in the apprehension of machine rhythms, in the conscious
awareness of a technological age. Consistent with this is the title, which
records the exact time taken to produce the painting, fifty-four minutes
of maximum concentration between twelve minutes past eleven P.M.
and six minutes past midnight. A short span indeed, yet the work itself
seems as instantaneous as a lightning flash. Obviously the painting
process, which demands a tremendous expenditure of energy, is
triggered off explosively at the moment of maximum concentration, yet
it often involves lengthy preparation. Sonderborg first sketches out in
a few rapid brushstrokes the general direction of the movement that
will determine the action. He then attacks the picture with brush,
scraper, palette knife, and even a windshield wiper. Colors are slashed
in and scratched out. Accents establishing forms are scraped in. Painter-
ly textures change into synchronistic impulses, energy becomes con-
cretized into form. Understandably, in the context of such swift
markings, notating force and movement, color possesses no particular
intrinsic value and plays at best a subordinate role. Harsh contrasts of
light and dark predominate, though sometimes an active and dynamic
red, for instance, will underpin the play of forces that have been
unleashed.

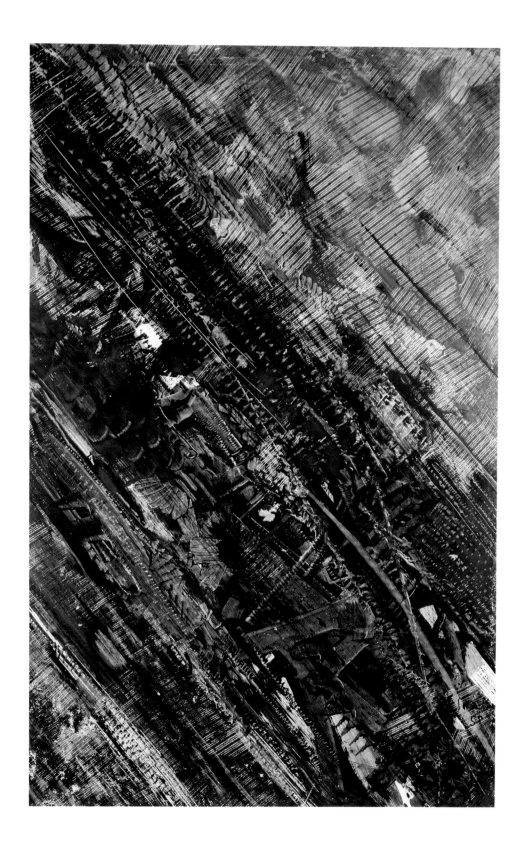

Colorplate 21

EMILIO VEDOVA (b. 1919)
Unquiet Space No. 5, 1956
Tempera on canvas, 44 × 44″ (110 × 110 cm)
Collection Mr. and Mrs. Robert Hermanos, New York

Vedova is one of the few Italian painters whose work touches closely on Abstract Expressionism. In *Unquiet Space No. 5* he attains a stormy high point, an instantaneous explosion of color and form. Splintery beams and aggressive wedges discharge their energies like lightning, dynamited fragments of shapes shatter in scorching swiftness to create a composition in which traditional ways of painting have been driven out by an unbridled spontaneity and dramatic action. In this unfettered dialogue of conflicting forces colors ricochet off one another. Refractions of red shoot across the surface, while here and there a livid yellow or sharp red flares up like a volcanic eruption. Flashes of brightness slash the pictorial space open to incalculable depths, carrying tensions to the brink of exploding the entire framework. The final disposition of the painting is not the result of planning. Formlessness is an adjunct to striving after expression at all costs, to the kind of "psychological improvisation" that was also exploited by Pollock, Hartung, Wols, and others of the Abstract Expressionist generation. The picture no longer has content or theme in the traditional sense but is the direct imprint of an existential moment. That it nonetheless remains recognizable as a picture, and, despite the dramatic violence of its handwriting, does not explode into total formlessness, is a matter of the intuitive capacity of the artist to recognize those limits beyond which the work would escape his control. Hence that dramatic moment in the art of our time when line, form, and color are liberated from the bonds of depiction and unfold their primal forces in an open-ended process of creation.

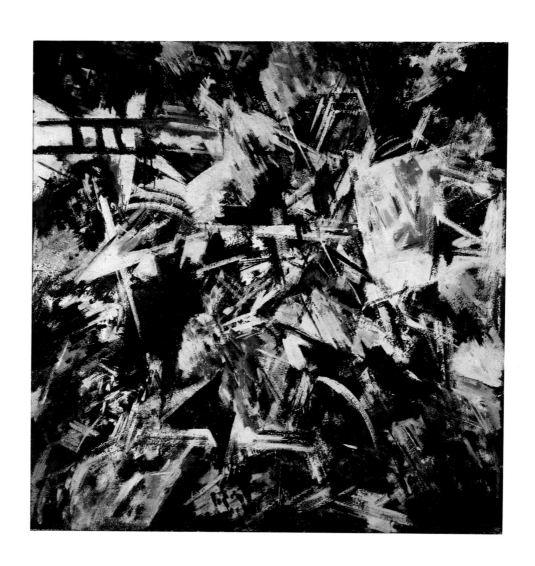

Colorplate 22

KAREL APPEL (b. 1921)
Burned Face, 1961
Oil on canvas, 118 × 78 $^3/_4$″ (325 × 200 cm)
Collection of the artist

The CoBrA group, of which the Dutch painter Karel Appel was a co-founder in 1948, is in some respects a European counterpart of the American Abstract Expressionists. They go even further than the Americans, however, in robustness and sheer fantasy. For Appel, painting is the spontaneous notation of inner feelings, a total self-expression intolerant of perfect painting technique because it may hinder the directness of the creative process. That is why, at first acquaintance, his pictures may seem overviolent and uncontrolled. The physical substance of the paint floods over the canvas from all sides, reflecting the furor of the act of painting. The intensity and dynamism of vehement colors, harsh contrasts, and brutal harmonies are visible proof of the artist's will to express himself to the fullest, uninhibited by any guidance from the intellect. Although always close to abstraction, Appel has not renounced all figurative associations. These, however, are not premeditated but arise as if by mere chance out of the undisciplined energy of the brush, the intricate mazes of color, the movement imparted to the raw stuff of paint; grimacing faces, demonic primordial beings, and creatures out of fable are wrested from the dark zones of the unconscious through an almost magical process of conjuration. What is at the start only a dim vision is pinned down in the course of work. The new-found image emerges from an expressive tangle of lines while remaining firmly embedded in the seething ground of the picture. Symbolic signs pregnant with meaning arise out of colors and forms set in motion by psychological impulses, and some sort of fragmentary yet objective setting becomes isolated out of the whole. Aptly termed "psychological automatism," this kind of pictorial invention, rich in suggestion and implication, reaches a high point in the work of Karel Appel. His art lies somewhere between pure self-expression—a dominant trend in nonobjective art—and the visionary process of evoking symbolic signs from an ancient primal unconscious. Both have their roots in the painting of Northern Europe and have been a part of that tradition since the early Middle Ages.

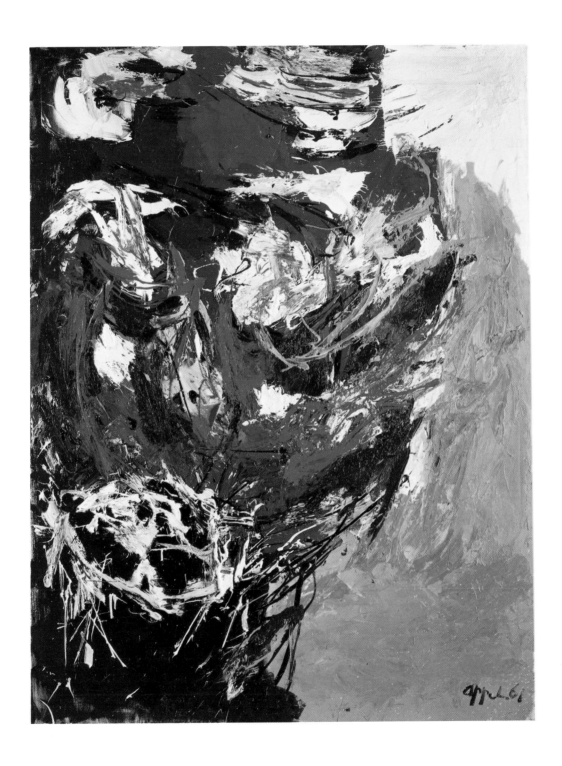

79

Colorplate 23

ASGER JORN (1914–73)
The Timid Proud One, 1957
Oil on canvas, 39 $^1/_2$ × 31 $^3/_4''$ (100.3 × 80.7 cm)
The Tate Gallery, London

Another founding member of CoBrA, the Dane Asger Jorn, worked in a manner intimately related in spirit to that of Karel Appel (colorplate 22), Pierre Alechinsky (fig. 12), and others in the group. But there is no mistaking the individual hands of these artists within their common commitment to a nonintellectual expressionism of the fantastic. Appel's brutal intensity and painterly robustness are countered by the magical character of Jorn's pictorial invention, which arises from no more than his movement of paint on the surface. If Jorn's art seems less spontaneous, it is also more evocative. Appel's riotous tangle of paint is treated as sheer substance with intense color values. In Jorn's more restrained and psychologically determined working of color and surface, the figurative image has taken shape as if from some ritual process of creation. Yet with Jorn one never doubts that such figuration was unforeseen at the start. Images attained form and substance only when he finished this picture by incising sharp lines into the paint that turned out to be, surprisingly, eyes and a mouth. Suddenly a face appeared within what, to that moment, had been no more than stirred-up paint, a face made clownlike by caricatural exaggeration. At the lower right margin in this painting, a few relatively cheerful tones underscore and enhance the ironic character of the depiction. Precisely because of their limited role in the picture, the passages of red provide a significant contrast to the general color scale of cool values, stated chiefly in modulations from green to blue. This "cooling down" of color values has the effect of distancing one's senses, which is atypical of most Abstract Expressionism. It dampens down agitation and mutes the impression of unbridled impetuousness, adding to the animated handwriting an overtone of ironic wit.

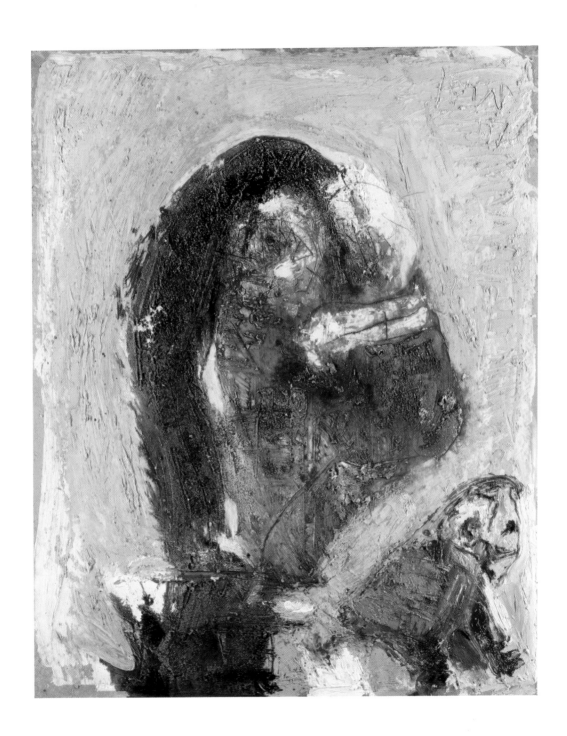

Colorplate 24

JEAN DUBUFFET (b. 1901)
Grand Portrait Mythe Supervielle (Jules Supervielle, Large Banner Portrait), 1945

Oil on canvas, 51 $^1/_2$ × 38 $^1/_2$″ (130.8 × 97.8 cm)
The Art Institute of Chicago. Gift of Mr. and Mrs. Maurice Culberg

This "portrait" seems to confirm every prejudice against modern art. The surface of the picture looks raw and disordered, with every refined aesthetic effect deliberately avoided. A funny, grimacing face, like a childish scribble on a weathered wall, is incised with deep furrows into a thick impasto of paint. The rudimentary head is crammed into the space like a primitive caricature. Color is important only as overall tone, and the paint seems to have been slapped on with a palette knife in utter disregard—or contempt—for the entire tradition of fine craftsmanship in art. In short, the nonartistic, grotesque, absurd picturing that the Frenchman Jean Dubuffet introduced in 1945 opposed everything then looked on as art. He called it "Art brut"—crude, raw, brute art—to announce that these seemingly naive, unrefined, infantile works were intended as denials of the sacred French tradition of exquisitely cultivated painting.

Dubuffet's works look natural, uncultivated, unschooled. Unformed matter covers the canvas with a virtually three-dimensional texture that has been incised with graffiti and worn by time and chance. The raw material conceals—and reveals—a wealth of shapes, figures, and phenomena which the artist brings forth as he wills. His sympathies lie with the irrational way children, naive artists, and the insane communicate through images, which had previously been unacceptable to "fine" artists. If such pictures are provoking or even upsetting, that is an important aspect of their attempt to evoke a powerful creative urgency and to touch on the depths of our capacity for feelings that are seldom exposed in any form of communication. Almost, though not quite without meaning to, Dubuffet forced art beyond its traditional limits, and did so in a way that proved exemplary for his and subsequent generations.

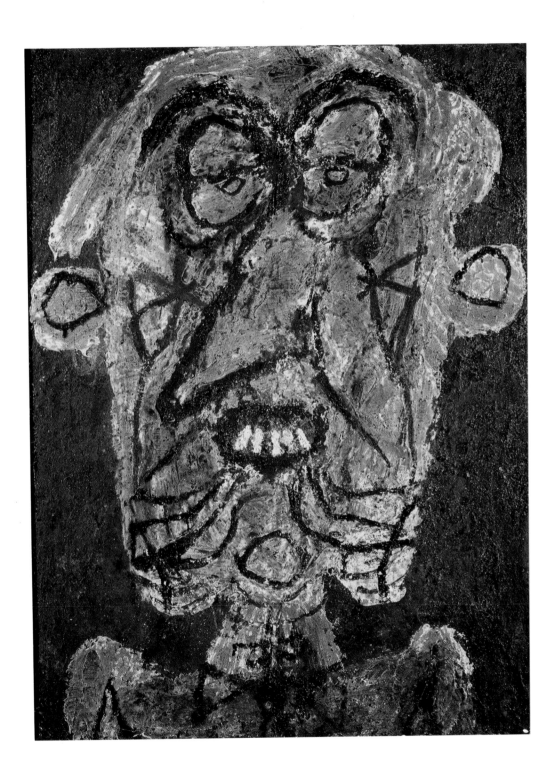

Colorplate 25

ANTONI TÀPIES (b. 1923)
LXVII, 1957
Mixed media on canvas, 76 $^3/_4$ × 44 $^7/_8$'' (195 × 114 cm)
Folkwang Museum, Essen

Tàpies belongs to the younger generation of Spanish artists who, in the
wake of the great pioneers Picasso, Gris, and Miró, have likewise left
their mark on the art of our century. His paintings, in which he uses
many materials besides paint, dispense with color harmonies, individual
handwriting, and subtle form. They are created from unformed matter
and bear the record of their fate like old walls or dark stones from some
primeval time, looking not like what we call art but like the end product
of a process taking place in nature itself. The effect is calculated in
Tàpies' use of paint mixed with sand and other substances to achieve
a rough, brittle surface marked by chinks and fissures. It is an artist's
conception, and yet the artist himself seems virtually excluded from
what looks like natural growth and decay. There is little direct evidence
of his hand, so scrupulously does he keep himself out of the picture.
At the most a few deeply incised signs at the lower edge of this work
indicate his intervention, signs or "wounds" which can be read as
human traces in what otherwise seems a natural object. Yet these
signs evoke the emotion-fraught solemnity and melancholy resonance
of this heavy, somber wall. The material itself gives rise to associations
with things seen and experienced, with the barrenness of Spanish land-
scape and weather-worn rocks, with puzzling textures that reveal them-
selves to the eye's intimacy. Such works of art disclose to the viewer a
new visual and emotional realm, that of the beauty and silent grandeur
of crude matter.

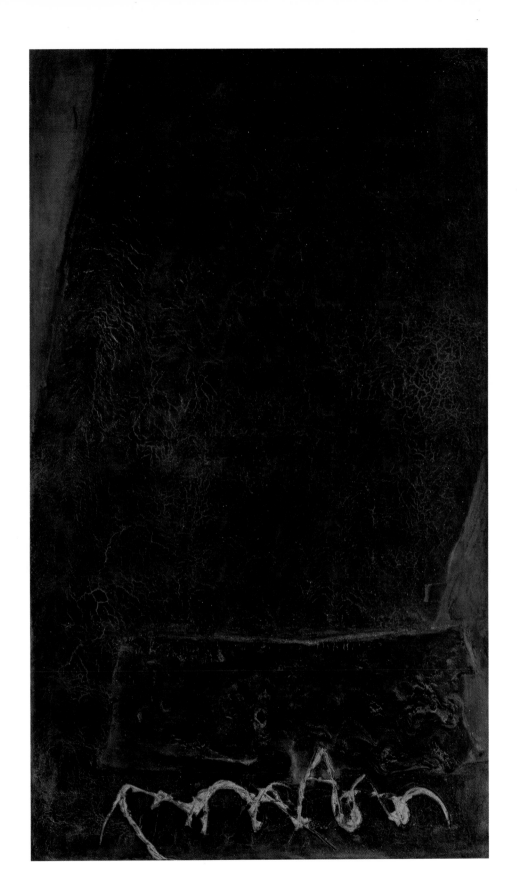

Colorplate 26

ALBERTO GIACOMETTI (1901–66)
Annette Seated, 1957
Oil on canvas, 39 $^1/_8$ × 23 $^7/_8$″ (99.5 × 60.5 cm)
Kunstsammlung Nordrhein-Westfalen, Düsseldorf

Although the Swiss sculptor Giacometti had painted since early youth, it was not until after World War II that he became known as a painter to the public. In his painting as in his sculpture the human figure is the focus of concentration, though his concern was not with outward appearance but with an image reflecting an inward state of fear and despair. It is an attitude that clearly marks him as an artist of his time, but the works themselves prove how difficult it is to assign specific artistic expressions to one style or another. Quite simply, what Giacometti did was outside the usual categories.

In this portrait of his wife, the subject is seated at the center of a bewilderingly empty room or space in which the eye seeks in vain for any fixed point of reference. Even the lines that frame the figure reinforce the impreciseness of the setting, as do the colors. Indefinite gray tones waver inconstantly around the fragile figure, symbolizing the forlornness, vulnerability, and imponderability of physical existence in a mood of frightening despondency. Though the portrait still resembles a particular person, the individual is now seen as part of the universal human condition of utter and absolute aloneness. Grayness surrounds and isolates the figure in an ominous, mystical configuration of shadow, evoking an oppressive feeling and expressing the artist's attitude toward reality. Reality is a shadow in which physical being is subject to a less certain spiritual being. Giacometti is the Existentialist artist who reveals man's exposure to some dire fate in the ghostly bareness of this room-as-world.

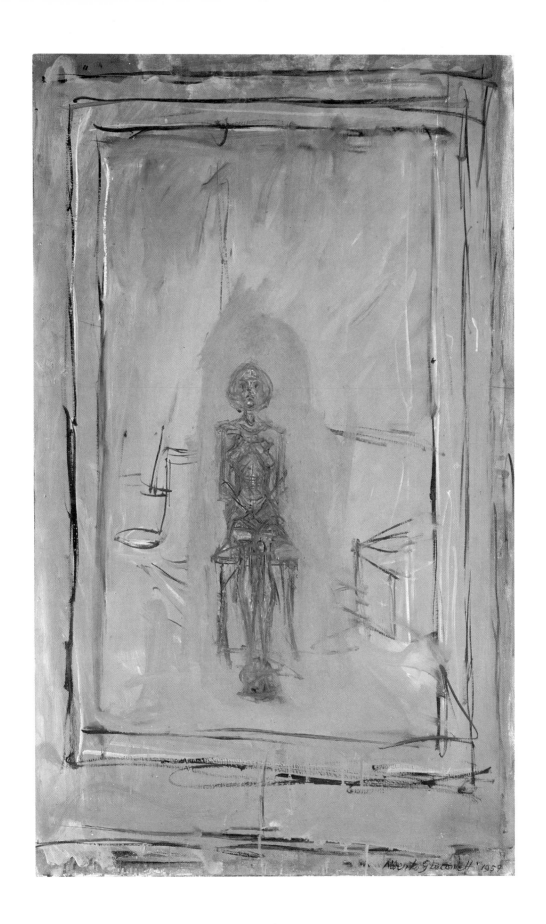

Colorplate 27

FRANCIS BACON (b. 1909)
Figure with Meat, 1954
Oil on canvas, 50 $^7/_8$ × 48″ (129.2 × 121.9 cm)
The Art Institute of Chicago. Harriott A. Fox Fund

The assault on the classical human image in postwar art is no more clearly shown than in the work of the British painter Francis Bacon. With obsessional one-sidedness he renders the human being as metaphor of a world of gloom and horror in which the individual long ago lost his value and now appears only as symbol for the artist's own feelings translated into sinister visions. The mind's lack of freedom is given its visual equivalent: the human creature caged in a pictorial space with markedly foreshortened perspective pressing in from all sides, its phantom form struggling vainly to break the shackles that pin it to the picture ground. Images of horror out of the deepest zones of the subconscious are made visible. Painting becomes an effort to master an alarming destiny, a means of exorcism.

The symbolic language of this picture is rooted in both its content and its pictorial means. In what remains of a once commanding pose and the indication of a throne we recognize the seated man to be Pope Innocent X from the painting by Velásquez on which Bacon had already produced a series of disconcerting variations. The figure's position is unstable. He seems to be sinking slowly in the foreground while his throne, in a horrendous apotheosis of power, is elongated into the two halves of a slaughtered cow which extend to the upper edge of the picture. The face is almost unrecognizable, yet one makes out a mouth opened in a scream that dies away even before it is heard: a symbol of tormenting loneliness in an isolating gloom of livid, sickly color broken only by a few phosphorescing glints of light. Blasphemy? Revolutionary attitudinizing? Neither, certainly. Rather, it is an image of the brittle, collapsing existence of man in our contemporary world, an image of art as hallucinatory antitype to an illusionless reality.

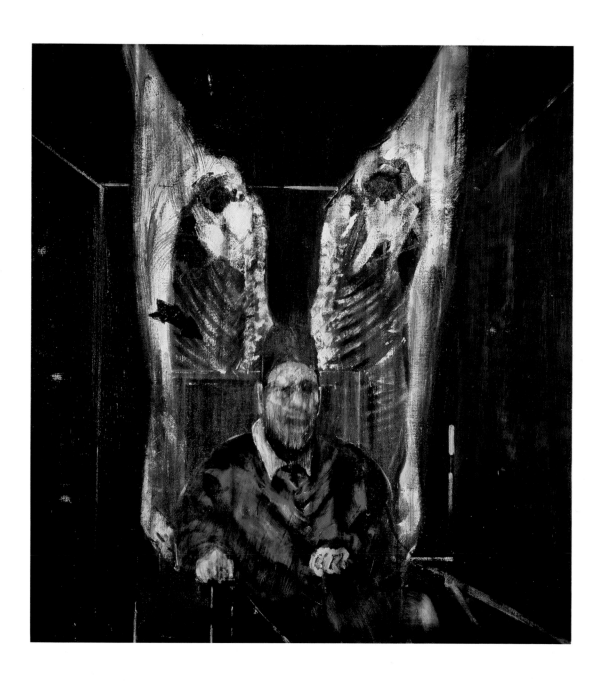

Colorplate 28

BEN NICHOLSON (b. 1894)
Still Life June 4, 1949 (Diagonal), 1949
Oil and pencil on board, 23 $^3/_4$ × 18 $^1/_4$" (60.3 × 46.4 cm)
The Hirshhorn Museum and Sculpture Garden, Smithsonian
Institution, Washington, D.C.

During the years when artists in the United States and Continental
Europe were chiefly concerned with the problems of Abstract Expres-
sionism, a British painter, Ben Nicholson, developed into a very per-
sonal pictorial form the ideas promoted by the Parisian Abstraction-
Création group. This still life of 1949 demonstrates his individual inter-
pretation of geometric forms. It may seem at first a purely concrete, or
abstract, composition. However, the choice of a still-life theme, to begin
with, tells us that the artist did not set out to assemble one of those cool,
rigorously geometric, formularized arrangements in which proportion
and not painting is the guiding principle. Neither is it meant to be un-
derstood and appreciated as a rational mathematical construction put
together from precise forms and pure colors and without a hint of
personal touch or feeling in its execution. This is not Nicholson's ap-
proach. For him geometry is a man-made formal method of controlling
the diversity of visible phenomena that lurk behind the systematic struc-
tures of abstract compositions. That is clear here, where the objects and
motifs are always the points of departure for building up an architec-
tonically ordered structure. Everything discloses such a rich, inherent
life that the picture strikes us as an equation on its own, a parallel to the
figuration of real things, rather than a rigid geometric arrangement.
Color is used with restraint, though a few brighter tones accent the
otherwise cool and elegantly balanced tonality of the ground. By juxta-
posing rigorous and freely drawn linear elements a tension is set up
between freedom and necessity. What the artist was after is perfectly
clear: to use a personal style of stringent clarity and formal euphony in
such a way as to construct the universal harmony he found in the
higher, poetic order of ordinary things.

90

Colorplate 29

JOSEF ALBERS (1888–1976)
Homage to the Square: White Island, 1961
Oil on composition board, 48 × 48″ (122 × 122 cm)
Folkwang Museum, Essen

In the years after Abstract Expressionism only a very few artists have had anything like the international influence of Josef Albers. A teacher at the Bauhaus, he was forced to emigrate in 1933 to the United States, where he later became an important mentor of the American avant-garde. In 1963 he published his *Interaction of Color*, a treatise summing up decades of study and research. According to his fundamental principle, a color is to be defined not in and of itself but only in relation to another color. However specific, a color will invariably change in character and value when brought into contact with some other color. His conclusions were exemplified in a series of paintings titled "Homage to the Square," to which he continued to add until his death. In this series Albers made use of different-colored squares set within one another, thus making not a picture in the traditional sense but a color scheme which gives the particular work its unmistakable identity along with a feeling of spatiality. The central white and the bright framing of *White Island* modify the intermediate gray zone in such a way that the edge toward the lighter color appears darker, and that toward the darker color lighter. The gray looks greener toward the white, whiter toward the green; two unrelated colors become related through a third. Further, one can perceive the white as receding into the depths or, then again, as coming forward; spatial values become altered within the composition. Thus the painting acquires its effect and vitality from the optical processes it explores.

Certainly Albers' findings exercised a strong influence on Op art, which is concerned with the exclusively visual effects of color and form. However, the importance of his thoroughly worked-out and exemplified ideas goes beyond that. They transmitted the experiences gained over half a century, beginning with the European Constructivists, to a younger generation of artists, no longer satisfied with an emotional use of color, who were thereby helped to take the decisive step into the new approaches of the 1960s.

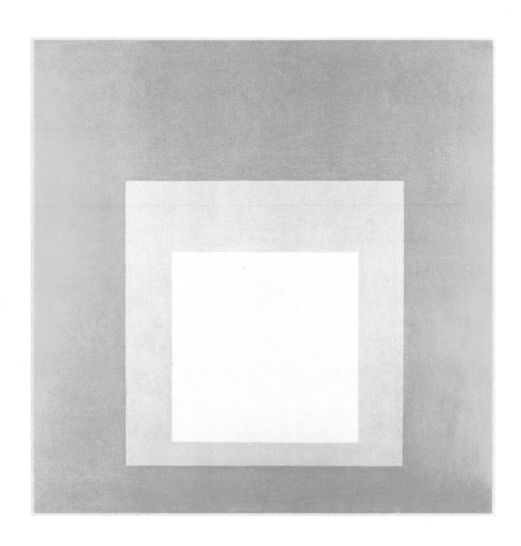

93

Colorplate 30

FRANK STELLA (b. 1936)
Sinjerli Variation I, 1968

Fluorescent acrylic on canvas, diameter 10′ (305 cm)
On extended loan to The Solomon R. Guggenheim Museum, New York, from the Harry N. Abrams Family Collection

Toward the close of the 1950s, a number of American painters, reacting against Abstract Expressionism, began to deemphasize the emotional overburdening of pictorial materials. Colors lost their expressive connotations, and formlessness was replaced by an almost aggressive assertion of basic, or "minimal," form. Among the major representatives of this so-called Post-Painterly Abstraction were Frank Stella and Ellsworth Kelly (fig. 16). In Stella's "shaped canvases," from 1960 on, the shape of the image and the shape of the canvas itself become so inherently linked that we apprehend them together. These colored structures no longer present an image, they *are* the image—depicted and depiction become identical. The unusual pictorial form of *Sinjerli Variation I* represents neither a youthfully bold attempt to violate convention nor an attention-getting revolutionary pose, but is rather a step in a long progress toward simplicity and clarity of form. The circular format is determined by the concentric colored half-circles, which, however, are subject to greater displacement from the central horizontal dividing line as they decrease in size. A further disturbance in proportional equilibrium results from the overlappings in the lower left half. Both devices run counter to the absolute geometry of pictorial form that the European Constructivist tradition accepted as basic principle. Stella's work remains open, deliberately trespasses beyond its borders into the space around it, and, in doing so, cancels out its two-dimensionality. In addition, color contrasts and tensions arouse visual irritations which emphasize the lack of relation among the potentially harmonious geometric shapes. Such harsh contradiction and severity are characteristic of New York art of the 1960s.

Colorplate 31

MORRIS LOUIS (1912–62)
High, 1959

Acrylic resin paint on canvas, 138 × 101″ (351.5 × 256.5 cm)
Dallas Museum of Fine Arts, Dallas, Texas

In the "veil" paintings done between 1954 and 1959 by Morris Louis, American color-field painting achieved its most differentiated painterly expression and greatest visual sensitivity. His sensitive tuning of stretches of color that seem to float across the canvas with no more force than a breath depends on the way he applied paint, almost without body or substance, so that color and canvas are imperceptibly wedded. The canvas seems not painted but imbued with color, stained or dyed to create a homogeneous field of light. The staining technique was first introduced by Jackson Pollock, but it was a 1952 painting by Helen Frankenthaler that impressed Louis with its possibilities. For Louis it involved pouring highly diluted solutions of paint in transparent layers on the canvas, either laid out flat on the floor or slightly inclined. This excluded brushwork and therefore all evidence of his own hand, eliminating what had been considered the very hallmark of artistic individuality. Certainly the newer procedure is not easier; it requires the utmost concentration because corrections are impossible. Painstakingly, Louis acquired the skill of controlling the flow of paint so that it appears not applied to but emerging from the canvas, which enhances the effect by retaining its own texture. The impressionistically mobile configurations create an ineffable interweaving of color and substance that contrasts sharply with the harsher approach of the New York School.

Colorplate 32

KENNETH NOLAND (b. 1924)
Swing, 1964.

Acrylic on canvas, 98 $^7/_8$ × 98 $^1/_8''$ (251 × 249 cm)
Kunstsammlung Nordrhein-Westfalen, Düsseldorf

With its new understanding of color, its smoothly uniform application of paint, and its direct exploitation of geometric forms, the work of Kenneth Noland breaks totally with the Abstract Expressionist approach. Much cooler and less emotional, it nonetheless avoids classical quietude and balance. The forms in this painting are purely geometric, yet the relationship between the three colored stripes and the diamond (or square) format sets up an opposition and sense dynamic propulsion which is emphasized by the unresolved progression of colors in the right-angled bands. The color itself, in terms of Goethe's theory, involves combinations that are "characteristic" (blue and red) and "characterless" (yellow and green), and both strong and weak contrasts are further emphasized by marked brilliance and variety. Color is no longer a medium of emotion or expression but is used purely for its own qualities and pictorial possibilities. Noland also avoids the imposition of personality by deemphasizing brushwork, using virtually homogeneous acrylics rather than oil paints, with all their sensuousness and physical presence. The ground of the canvas is neutralized by being left bare, to act not as a field of space but simply as a light field that complements and completes the colors applied. This does not exclude the spatial effect inherent in the colors but furthers the clear tensions among colors, thereby introducing a dynamic element into what is otherwise a formally equilibrated composition. Just as the tyranny of rigorous form is tempered by a certain liberty in treating the edges of forms, the hermetic principle of pure geometry is tempered by a free and imaginative interpretation of color. This is the theme, content, and purpose of the picture, accomplished with the grandiose thoroughness and logic that was characteristic of American painting in the wake of Abstract Expressionism.

Colorplate 33

HEINZ MACK (b. 1931)
White on White, 1959
Bakelite on muslin, 59 × 47 ¹/₄″ (150 × 120 cm)
Nationalgalerie, West Berlin

This painting obviously turns its back on the traditional criteria of painting, but it also takes its distance—a considerable distance—from Informal art and Abstract Expressionism. Here an artist of the following generation, reacting against an outworn mode, sought to redefine color, pictorial space, and even painting itself. The involvement with paint as a material with its own inherent expressive possibilities—the problem engaged by painters like Pollock, Tobey, Dubuffet—had lost its fascination. What remained was the conception of pictorial space those painters had developed, but without the cosmic overtones or the tension-creating contrasts of form and space. In Mack's work, space and form are identical, part of the same texture, the same monochromatic surface. Color plays a part only as a sensitive modulation of a specific tone—in this case, white—and, as such, functions also as form. In place of pictorial composition is a structure of parallel lines which occur in an infinitely variable succession that creates an optically vibrating space within the picture. The traditional contrast between form and void is thereby abolished. Mack himself has described this process: "Painting, as dynamic texture, which is satisfactory in itself, evinces a new vitality of the painterly nuance. . . . The exclusivity of a dynamic pictorial texture free of all figuration, astronomically remote from nature, becomes the expression of a pure emotion: it presents itself as new reality whose secret beauty we sense." Mack has produced only a few pictures, and they mark the experimental phase of his progress toward light as formative energy, which has been the specific goal of the Zero group since he founded it in Düsseldorf with Otto Piene and Günther Uecker in 1957.

Colorplate 34

OTTO PIENE (b. 1928)
The Sun Burns, 1966
Oil and fixative on canvas, 39 $^3/_8$ × 51 $^1/_8$″ (100 × 130 cm)
Kunstmuseum, Düsseldorf

Another member of the Zero group of Düsseldorf, which began to react
in the 1950s to the dramatic excesses and self-involvement of Abstract
Expressionism, was Otto Piene. As Heinz Mack (colorplate 33) canceled
out the artist's personal handwriting in favor of impersonal pictorial
textures, Piene explored other ways of overcoming the intense subjec-
tivity of the creative process. His so-called "smoke pictures" pointed the
way toward the fully objective painting. In them he attempted to go
beyond the material character of paint, with all that it suggests of per-
sonality and emotion, by avoiding direct contact between painter and
canvas. He replaced the brush with candles or oil lamps, manipulated
the resulting deposit of soot on the canvas until an image took shape,
then treated the whole with varnishes and fixatives. The definitive image,
however, was not left to chance. The artist guided the process through-
out, even if it looks, in the final result, as if the picture had painted
itself. This means that his own emotions—here felt in the association
with what is, after all, an unnaturalistic nature—are carried over into
the work. When the canvas is exposed to smoke, concentric circles, with
their own inner vibrations, appear to spread like waves that have been
deliberately and consciously controlled. Though light does not even
register as a dominant brightness, one apprehends it, nonetheless, as
"dark light" filling a glowing, dark red cosmic landscape defining and
encompassing the pictorial space itself. The ultimate result is a new
nature, one imbued with a quality that can unhesitatingly be called
"romantic," though the artist has made no attempt to imitate visual
reality.

Colorplate 35

VICTOR VASARELY (b. 1908)
Arcturus II, 1966

Oil on canvas, 63 × 62 $^7/_8$″ (160 × 159.7 cm)
The Hirshhorn Museum and Sculpture Garden, Smithsonian
Institution, Washington, D.C.

The formal concept of this painting is as simple as its colors. The system is one of squares within squares encompassed by an overall grid. Each of the small squares is painted in a modulation of the specific colors established by the four adjacent large squares. Color and form together give rise to a strong optical irritation or, more precisely, a spatial illusion. Tones lighten toward the centers of the four large units with mathematical precision, creating the optical impression of a three-dimensional perspective in each. Since the eye perceives color relationships as spatial relationships, the color-shapes appear to be at different depths. To these receding pyramids with apexes marked by the brightest light the painter gave the name *unités plastiques*.

As in all Op art, the theme or content of the work is entirely visual and involves a deliberate and skillful manipulation by the artist of our visual experience. We follow, step by step, the way the basic structural units are added on, which results in ever more complicated, though always consciously programmed, processes involving color and form. The fact that they are architectonic elements accords with Vasarely's conviction that his works should be understood not as objects of aesthetic contemplation but as basic patterns that can bring a note of humanity into the bleak mass production of contemporary urban architecture. They are part of a systematic planning intended to be put to practical use: the colorful city as living space of the future.

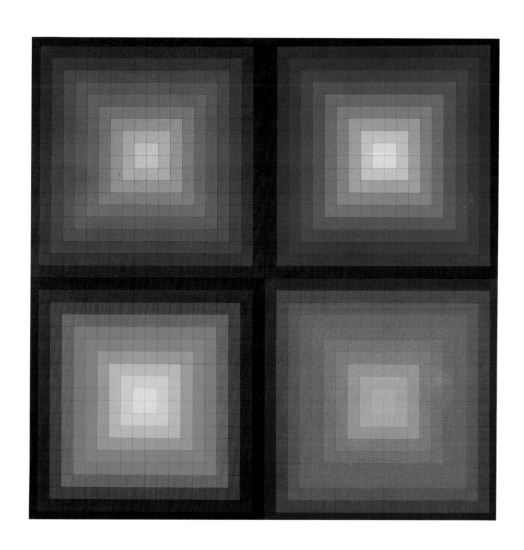

Colorplate 36

ARMAN (ARMAND FERNÁNDEZ; b. 1928)
Petite Polychromie (Small Polychromy), 1967
"Accumulation" of paint tubes and ribbons of paint in polyester,
$42\,^1/_2 \times 41\,^7/_8''$ (108 × 106.4 cm)
The Harry N. Abrams Family Collection

Arman was a founder in 1960 of the Nouveau Réalisme movement in Paris, which, after a decade dominated by Informal art, championed a return to reality. Reality in the new conception, however, was not to be imitated and depicted, as in American Pop painting, but incorporated directly into the work of art. Thus Arman relies on real objects, on the banal debris of mass production, on odds and ends of everyday things no longer of any use, to assemble a counterimage of reality. Obviously the lessons of abstract painting are important in the artist's approach to these raw materials and are what lend his works their unique aesthetic effectiveness and underlying poetry. But, even if color still constitutes a fundamental value, the painting itself has become unequivocally an object. What impelled the artist to make real tubes of paint part of his conception in this work was not pleasure in painting as such but, rather, the pure, objective, physical property of paint in its most mundane form. The paint tubes literally represent reality, while also serving as a point of departure for a rhythmic, colorful, fascinating image that looks very like an abstract painting. However one may choose to regard these rigid streams of color, they do show all the properties we associate with a work of creative art well removed from the banality of everyday reality. The choice of tubes and the way they are assembled is not a matter of accident or chance. Aesthetic considerations of form and color come into play, though we cannot say just how personally involved the artist is in a work that seems more a statement of fact than of personal commitment.

Colorplate 37

YVES KLEIN (1928–62)
MG 28, 1960, 1960
Gold leaf on canvas, 37 $^3/_8$ × 29 $^7/_8$″ (95 × 76 cm)
Folkwang Museum, Essen

The reaction of Yves Klein—a founder with Arman, Jean Tinguely, and others of Nouveau Réalisme in Paris—to the ideas behind non-objective art of the 1950s took the guise of a changed conception of paint and color. He directed his work, with unprecedented purity and impassiveness, toward the absolute. Paint was no longer a medium for expression or communication. Even its material properties were de-emphasized. For Klein, picture and color were one; the picture became color, and color the picture. Conceiving the picture as a pure color-object, he began to concentrate on a single color, styling himself "Klein le Monochrome." Precisely through such a rigorous and unusual restriction, new dimensions were opened to color. It took on a spiritual, symbolic character, even a kind of religious resonance. This explains Klein's preference for blue and gold, colors of particular immateriality and depth that have long had a special significance in Christian art. Blue suggests cosmic vastness, while gold serves as metaphor for meditation and, thus, for the life of the spirit. In this picture, individual pieces of gold leaf are fitted together in a kind of serial order that delicately animates the surface. This subtle play is enhanced by the weave of the canvas where it comes through, and by the addition of irregularly placed bits of gold leaf. Klein had spent some time in the Far East before settling in Paris in 1955, and he was no doubt influenced by Oriental ideas, those of Zen Buddhism in particular. This is evident in the idealism of his work, and, for instance, in his choice of gold, not for its material value but because of its traditional association, particularly in medieval painting, with a magically heightened reality.

Colorplate 38

ALLEN JONES (b. 1937)
Man Woman, 1963
Oil on canvas, 84 $^1/_2$ × 74 $^1/_4$″ (214.6 × 188.5 cm)
The Tate Gallery, London

Pop art emerged in England in the 1950s. Younger artists saw it not so much as a reflection of the new consumer society as an opportunity to develop a pictorial language outside the established values and conceptions. That the advent of Pop art sparked a renewal of figurative painting was hardly surprising in a country that had largely avoided the influence of Action Painting. For all the individual stamp of English Pop art, there was considerable give-and-take with its counterpart in the United States after 1960. The American R. B. Kitaj (colorplate 39), a product of Cooper Union in New York who was a fellow student with Allen Jones at the Royal College of Art in London, played an important role in this interchange. The Royal College group, which also included David Hockney (colorplate 40), showed their work beginning in 1961 at the Young Contemporaries Exhibitions and ushered in a new phase of Pop art in Britain. The urban environment continued to be the chief source of subject matter, now with a stock of themes more ready to hand: types and products in the broadest sense, the media and publicity images of big-city life. Beginning in 1962 Allen Jones made the erotic element the central focus of his work, often in a transposed or decorative form. Comparison with the paintings of Kitaj shows as many differences as common traits. They deal with form in a similar way, but in this work, for example, Jones proposes a relatively simple, directly comprehensible representation of a seated couple that is quite unlike Kitaj's complicated iconography. Sketchy as this painting is, it is the painterly values that predominate. The color is glowingly bright, the composition designed for visual rather than formal effect, and there is no doubt of the artist's reluctance to indulge in the obtrusively poster-like approach of New York Pop art. Even the eroticism is low-keyed and therefore registers as symbolic, not as something out of what Jones calls "a popular iconography."

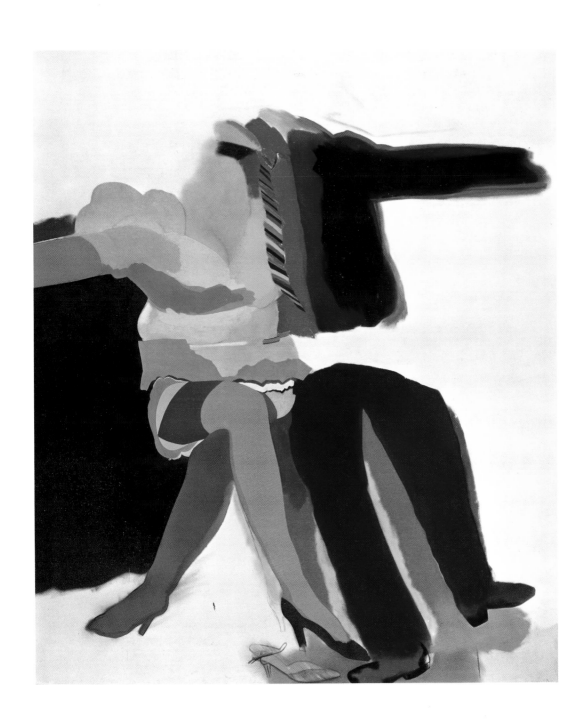

Colorplate 39

R. B. KITAJ (b. 1932)
The Ohio Gang, 1964
Oil and pencil on canvas, 72 × 72″ (183 × 183 cm)
The Museum of Modern Art, New York. Philip C. Johnson Fund

"I don't understand it, but its tone delights me." Wittgenstein's comment about Georg Trakl's poems, which was adopted by Kitaj as the motto for one of his catalogues, says something about the complexity of the work of this American painter, who has been part of the English art scene since the early 1960s. The title of this painting arouses expectations which the painting itself both reinforces and deflates. What seems to be an underworld scene, like something from an early gangster film, turns out to have a number of levels of meaning. The figures are distributed across the canvas in a manner resembling collage. There is no single viewing point. The separate episodes are linked by an inner connection that eludes description, despite the sharp characterizations of people. This ambiguity runs counter to the cards-on-the-table attitude of Pop art. Likewise the color values are more difficult to discern. Color is laid on so insubstantially and objectively as to make the painting look almost like a silkscreen print, which adds to the aura of anonymity. One has the sense of Surrealist cryptic significance, of an unsolved enigma in what looks like a realistic situation. The picture remains open-ended and continues to challenge the viewer to search out the hidden meanings that might account for the ambiguity of what is seen clearly enough.

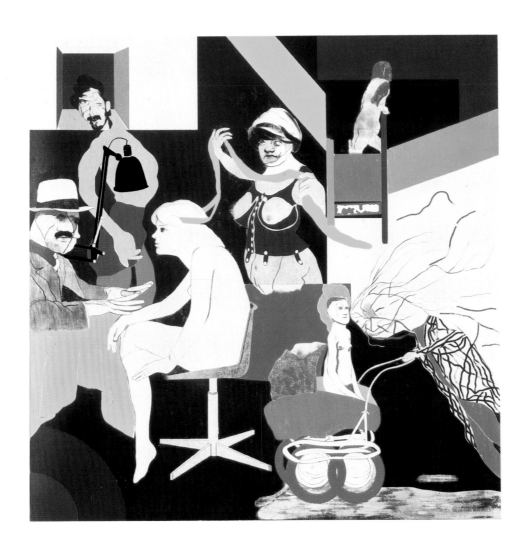

113

DAVID HOCKNEY (b. 1937)
Le Parc des Sources, Vichy, 1969–70
Acrylic on canvas, 84 × 120″ (213 × 305 cm)
Private collection, London
© David Hockney 1971

The city and park of Vichy so charmed the English painter David Hockney on his first visit in 1968 that he returned a year later to draw and photograph and then, in 1970, set to work on a large painting based on those studies. What intrigued him was not the beauty of the park's landscape, which he captured anyway, but the surreal quality he sensed in the allée that dominates the picture. Rendered in false perspective, with an exaggerated foreshortening of the rows of trees toward the rear, it provides the decisive accent, creating a V-shape that culminates at left of center and dominates the composition. This configuration also subjects the off-center figure group in the foreground to a strong inward pull. There is another surreal note in the group itself. The left-hand chair alongside those of Hockney's friends Peter Schlesinger and Ossie Clark is unoccupied; it symbolizes the artist himself, who had left the scene to paint it and thereby, in a sense, to return to it. Hockney's sense of color and form, and his commitment to real content, distinguishes his own photo-to-paint procedures from those of the Photo-realists. Details are played down, and artistic vision is emphasized over naturalism. Hockney has pointed out that the sort of photographic vision favored at that moment would have negated the surreal effect and emotional implications he felt so strongly. For that reason also he kept his distance from nature in the use of paint and color. The flat, artificial colors combine with abstracted forms and shapes to create an image removed from photographic realism.

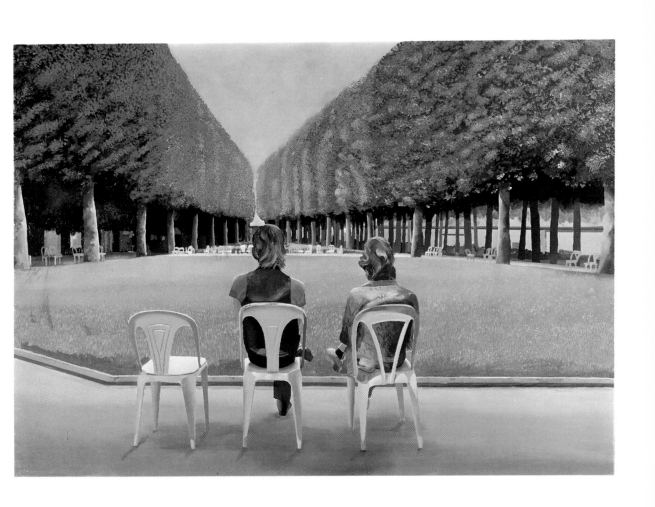

JASPER JOHNS (b. 1930)
Flag Above White, 1955
Encaustic and collage on canvas, 22 × 19″ (55.9 × 43.8 cm)
Private collection

Jasper Johns was among the first of his generation to turn away from Abstract Expressionism. The paintings he did as early as 1954 and 1955 show him developing away from the emotional gesture on canvas toward a new conception of reality that was to have an important influence in the development of Pop art. He went beyond the historical step taken by Marcel Duchamp in the "Readymades" that had inspired so many artists, neither embodying reality directly into his paintings nor settling for true-to-life imitation. His aim instead was to fuse picture and object into a reality ultimately independent of both those approaches, one in which the question of any connection with reality would become meaningless. In this early painting from the famous series of "Flags," there are still traces of experimentation, particularly in a format that still emphasizes the fact that this is a picture rather than a flag. In addition, the use of printed material underneath the encaustic surface still places the picture in the collage tradition, both technically and in the final aesthetic result. The broad brushwork still gives evidence of the artist's own hand and his origins in Abstract Expressionism. Yet the composition itself is already largely free of emotion, and the matter-of-fact treatment of the subject, reduced to a neat facsimile, denies its inculturated symbolic weight. These contradictions between traditional painterly concerns and the projection of a new reality, the painting as coolly observed object, were fully resolved in Johns' subsequent pictures in this series.

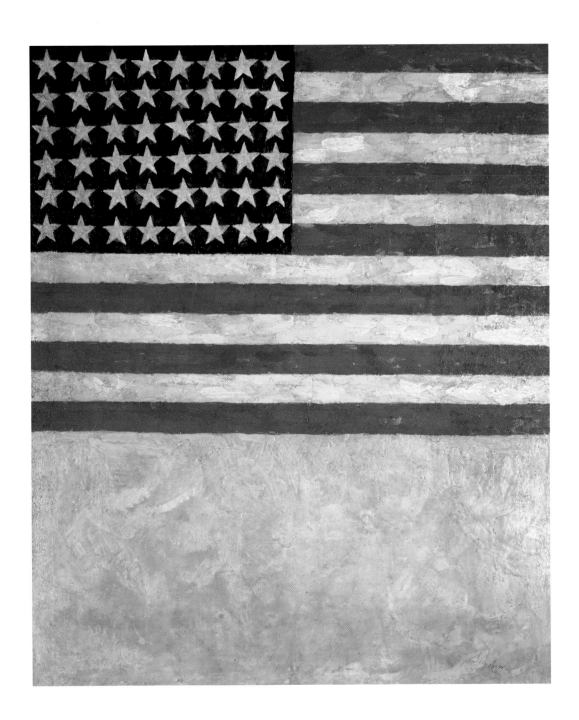

Colorplate 42

ROBERT RAUSCHENBERG (b. 1925)
Buffalo, 1964
Oil over silkscreen on canvas, 96 × 72″ (243.8 × 182.9 cm)
Collection Mrs. Robert Mayer, Winnetka, Illinois

In this work painting becomes an adjunct of mechanical reproduction. Its surface is crammed with silkscreen imprints of photographs and newspaper clippings, the fall-out of our everyday media-dominated world, assembled into a huge collage. The assemblage of preexisting images seems at first unselective or, at best, dictated by exclusively compositional considerations. This is not the highly poetic world of objects the Surrealists had conjured up decades earlier using similar techniques and materials. Rather it represents a perception of contemporary history that combines public manifestations—the photos of John Kennedy and the repeated gesture of his hand, the American eagle, a cafeteria, Coca-Cola ads—with Rauschenberg's own personal vocabulary of forms, which are often repeated in other works of those years—the key, the parachutist, reproductions of old-master paintings. In this mixture of the durable and the ephemeral, values are represented by cast-off scraps of no value, and familiar symbols, because of the way they are cited, lose their original significance, becoming objectified, distanced, into fragments of the composition. Meaning resides not in the deciphering of allusions, but in a world that deliberately rejects craftsmanship and permanence, and is based on the throwaway products of the mass media, which the artist rescues and reactivates as pictorial objects, thereby imbuing them with a new positive, though now alienated, existence. In this context, painting is simply one element among others, neither more important nor less, with the specific task of facilitating visual transitions. Artistic dignity is retained in bold brushwork, but it is treated ironically in relationship to the photographic images and to the exaggerated scale; the classical work of art is called into question.

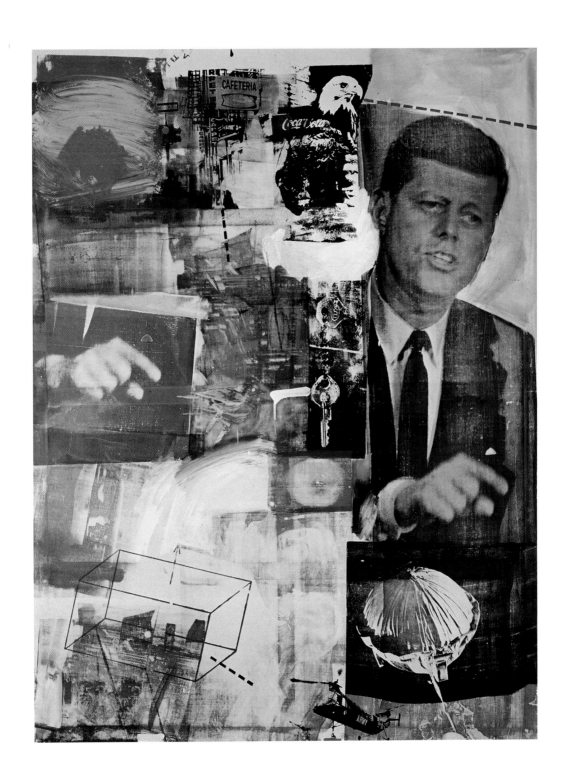

Colorplate 43

ANDY WARHOL (b. 1930)
Marilyn, 1962
Silkscreen on canvas, 20 × 16″ (51 × 40.5 cm)
Collection Mr. and Mrs. Leo Castelli

No artist was ever so much the symbol of the life-style of a specific time and social climate as Andy Warhol. Works like his Campbell's soup cans and his serial portraits of Marilyn Monroe have become virtual trademarks for the consumer madness, the power of the mass media, and the exaggerated star cult of the 1960s. They also represent an extreme position in the art of the time. Impersonal, and as readily reproducible as a photo or print, the new Pop-art realism has become as inseparable from visual mass production as films, posters, and magazines. In this painting, based on a photograph, portraiture is no longer a matter of relationship between painter and sitter. Rather than painted, it was produced by the silkscreen method used for posters and prints, which does away with all trace of the artist's hand and suppresses any individuality in the creative process. Personal traits are of no significance in an age when content and values, human faces and attitudes, have been leveled to a common denominator. Warhol did not produce his portrait until after the actress's death, at a time when her face still smiled from every billboard announcing her latest film, a bitter memento mori guaranteeing her a life beyond death in precisely the medium that made her a star. The use of different, though always synthetic, colors for each painting in the series, the stenciled sameness of one face after the other, and the manufactured look of the star herself are matched in alienation by the artificial character of an art work totally without emotion. Sympathy is neither requested nor given; the individual is degraded into an exchangeable type. The image reflects the oppressive anonymity of a human being caught in a mass-media publicity machine from which she can never escape.

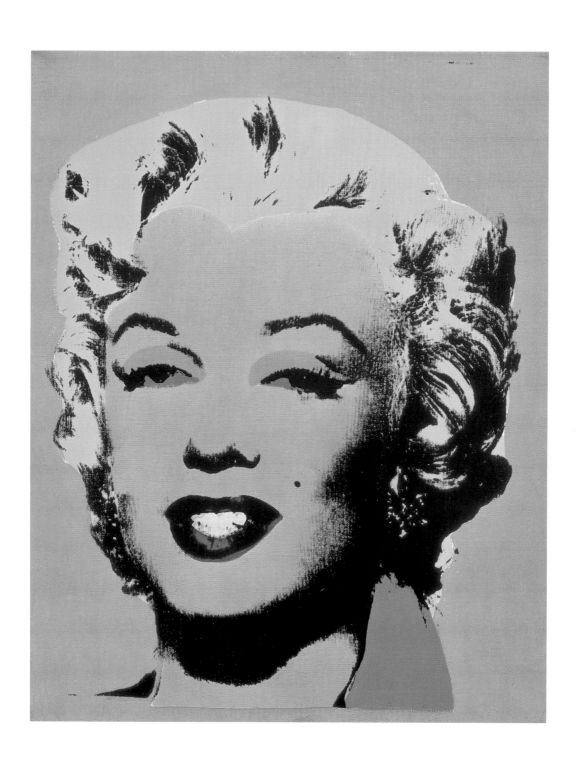

Colorplate 44

ROY LICHTENSTEIN (b. 1923)
Woman with Flowered Hat, 1963
Oil on canvas, 50 × 40″ (127 × 101.6 cm)
Collection Mr. and Mrs. S. I. Newhouse, Jr., New York

Lichtenstein's version of Picasso's portrait resembles a coarsened and overenlarged screenprint of the sort found in newspapers and cheap magazines, an alienated parody of the original. Deliberately eliminated is Picasso's personal touch, his dramatic feeling for form, and the tensions of his colors. Yet Picasso remains, if only in what looks like a bad reproduction, with painting translated into graphic elements. His subject, forms, and composition survive in the concentrated, strongly simplified sign language of a poster-like representation. Color is stripped of its original artistic value. Reduced to flat notations, the bald contrasts imitate the patterns of comic strips and cartoons. Like other Pop artists, Lichtenstein subjected the original to the formulas of mass communication in their most trivial and tawdry form. Art no longer has an ethical value, as something unique, but becomes an easily reproduced, mechanized emblem to be translated ad infinitum into the language of a consumer society indifferent to quality, a denial of the classical tradition represented by Picasso for so long. But this sort of transformation is not to be understood as pure persiflage. The replacement of traditional art with a mindless assembly-line product, a utilitarian object, represents a changed feeling for aesthetic quality, but the work lacks neither spirit nor sense. A certain power of invention resides in using one image to create a new and just as individual image. The fact that Lichtenstein no longer bothers with the traditional notion of art, that he sets original and imitation on the same plane, makes his work characteristic of a period of American realism that has had an enormous international influence.

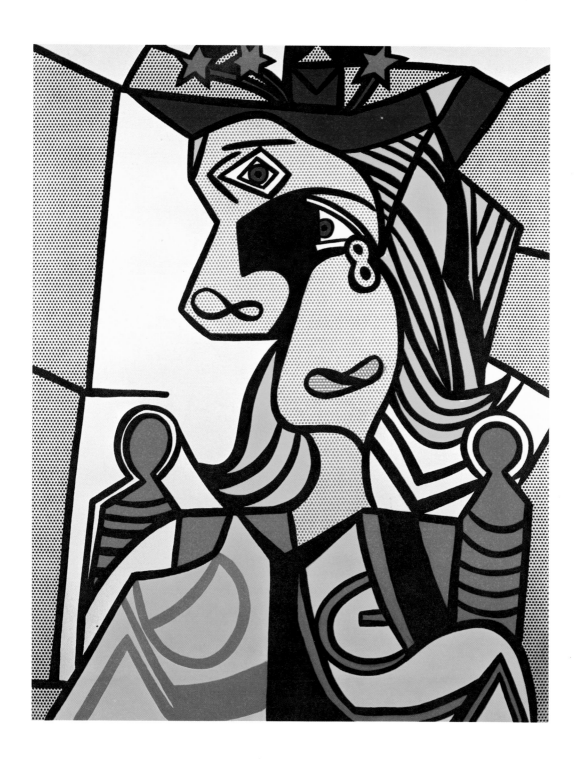

123

Colorplate 45

RICHARD LINDNER (1901–78)
42nd Street, 1964

Oil on canvas, 70 × 60″ (177.8 × 152.4 cm)
Collection Mrs. Elizabeth B. Blake, Dallas, Texas

Forty-second Street, New York: showplace of anything-goes amuse-
ment, erotic funfair of catchpenny pornography, simultaneous inferno
and garden of delights in a world capital rich in heady contrasts. The
German-born Richard Lindner, emigrant to France and then America
in the Hitler years, developed in the 1960s a pictorial vocabulary in
which he caught the unmistakable atmosphere of New York with a
directness of imagery and brutality of form that went far beyond any-
thing devised by the well-publicized Pop artists of that decade. The
picture looks, and is, lurid and loud. All details are shoved to the fore,
and push at the viewer. Depth is created not through perspective but
almost involuntarily through the spatial value of colors whose insistent
bright variety screws the hectic tone of the picture a pitch or more
higher. Through the centered keyhole, a frequent motif in Lindner's
work, is seen the head of a snarling tiger. The two adjacent female
masks, enclosed in an arc of marquee lights, look like some sort of erotic
heraldic sign, with their burning red lips contrasted to their cold blue
eyes. Makeup becomes mask, and everything human disappears behind
it. The two male profiles below, sharp as scissor-cut silhouettes, are
equally unfeeling and impersonal, phantoms in a world whose raw, hard
coloring does nothing to conceal their facelessness and brutality. In this
all-out, trenchant exaggeration there is still an unmistakable expression,
concealed as it may be, of the artist's personal attitude, distinguishing
it from the deadpan concept of reality of American Pop art.

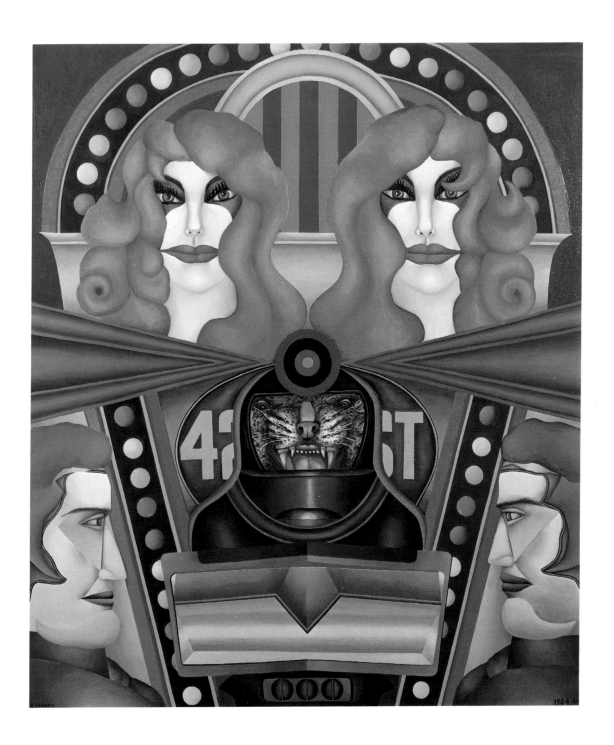

Colorplate 46

ROBERT INDIANA (b. 1928)
Yield Brother 2, 1963
Acrylic on canvas, 84 $^1/_2$ × 84 $^1/_2''$ (214.6 × 214.6 cm)
The Harry N. Abrams Family Collection

A traffic sign never seen before? Certainly the colors and forms of this painting suggest something very like a sign or signal. They demand attention, and direct the eye to the anonymous-looking stenciled lettering, which obviously has a particular significance. The simple scaffolding of pure geometric forms is laid out with rigorous symmetry. A few cool tones from blue to green are given additional tension by simple contrasts with red tones. The painting illustrates the principle of Josef Albers' "interaction of color" (colorplate 29): the lettering and inner circle have the same color value, but by contrast with blue the letters appear more intensely red, while the same red tones next to green have a stronger tendency toward orange. In a different way the effect of the lettered text is also equivocal; it reads both as a dramatic exhortation and as a dynamic component of the composition. Words as image are of course nothing new in twentieth-century painting; one thinks of Cubist paintings, Schwitters' collages, Dada picture-poems. Artists in both Europe and America subsequently returned to these early ventures and introduced personal variations. Indiana, however, takes a rather special place because he permits words to retain their meaning, so that in his pictures they have something of the urgency of invocations or appeals and, therefore, give new value to the picture as a vehicle of expression. Here he names members of the family. In other works words such as LOVE, EAT, DIE, ERR, HUG introduce value-references that raise his pictures above the general run of Pop art with its play on irrelevancies. The purely visual character of Indiana's coolly dissonant color abstractions and their commitment on a symbolic plane to point-blank comment on matters of the moment introduced a new resonance into American art through the union of geometry and poetry.

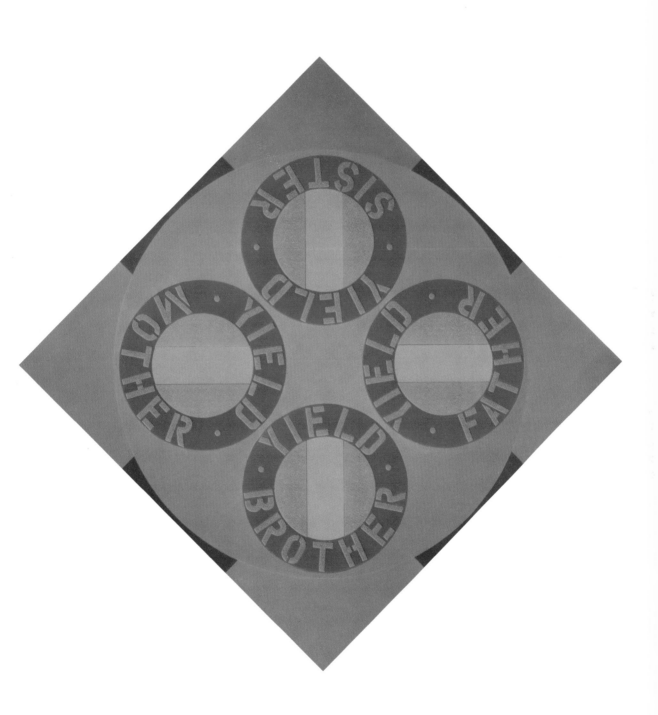

127

Colorplate 47

RICHARD ESTES (b. 1936)
Victory Theater, 1968
Oil on panel, 32 $^1/_2$ × 24″ (82.6 × 61 cm)
Collection Stephen D. Paine, Boston, Mass.

After Pop art had idealized the triviality of the everyday consumers'
paradise, setting it up as an emblematic reality, the Photorealists gave
such subjects an entirely different appearance. Explaining the point of
departure for his visual experience, the New York painter Richard Estes
insisted that taking the photo is as important as painting the picture.
Yet in his work there is no absolute identification between photography
and painting, nor does he accept the traditional limits of realism. To
begin with, the format of the picture is monumental compared to the
size of the slide, so that both the proportions and the displacement of
the normal viewing point create a visual distancing. Additionally, the
eye is capable neither of taking in the enormous number of realistic
details seen here nor of giving each the same flat, equal value. The
painting thus surpasses the possibilities of normal vision, bringing
everything into the same sharp focus and making no distinctions
between one part of the picture and another. The scene, as in Richard
Lindner's painting (colorplate 45), is 42d Street in New York. Though
that street is usually jammed with traffic, here life and movement appear
benumbed, and even the three human figures look frozen in place. This
supraphotographic, supraretinal manner of seeing, which extends the
realism of the picture's subject ad absurdum, and the transformation of
activity into a non-event, constitute stylistic hallmarks for many Photo-
realists. The artificial colors further drain life from the scene, con-
verting details into geometrically abstract forms. Color too is frozen.
Realness is processed out of things, and the eye is forced to grasp an
unnatural complexity. Reality becomes an illusion that elevates a new,
synthetic pictorial reality, a mixture of what the eye or camera actually
records and what the imagination produces.

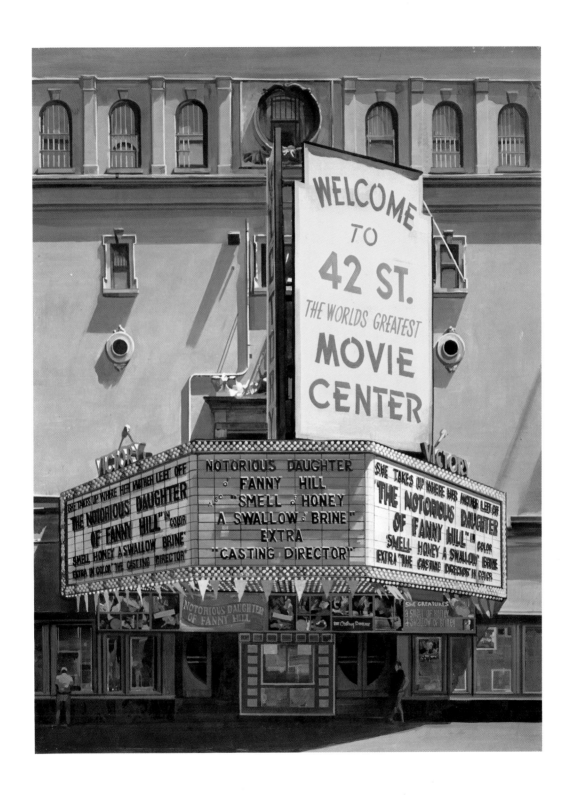

Colorplate 48

CHUCK CLOSE (b. 1940)
Linda, 1975–76
Acrylic on canvas, 106 $\frac{1}{4}$ × 82 $\frac{5}{8}$″ (270 × 210 cm)
Privatecollection

As a painting (which, after all, it is) this portrait is a reproduction of a reproduction, an irritating shift in those levels of reality we could still cope with in both painting and photography until the American Photorealists came along. But its practitioners are neither photographers doubling as painters nor the sort of extreme traditional realists who periodically appear. Instead, photography is the point of departure for a new "artificiality" (with a strong implication of both "art" and "artifice") sharply opposed to the "naturalness" that portraits are supposed to convey. The idea of the portrait as product of a psychological encounter between the artist and another human being is made obsolete, something we have already seen in the work of Andy Warhol (colorplate 43). With perfect consistency, Chuck Close accepts no commissions for portraits. The face he deals with offers him merely information, visual data on which he can operate, and the visual mechanism of the camera lens ensures him the most neutral, unemotional, and aloof close-up kind of observation. The cool snapshot-like citation of the subject (the "object") replaces psychological processes that informed earlier portraiture. The result is anonymous yet as full of suggestion as a film poster: a perfect visual formula which, though achieved with realistic means, goes far beyond reality. "Likeness is an automatic by-product of what I do, an attempt to find methods or means to carry out the translation of those elements into a painting," says Close. Here, then, in place of pictorial reality we have the picture as new reality, a kind of hybrid or, some may say, monster.

130

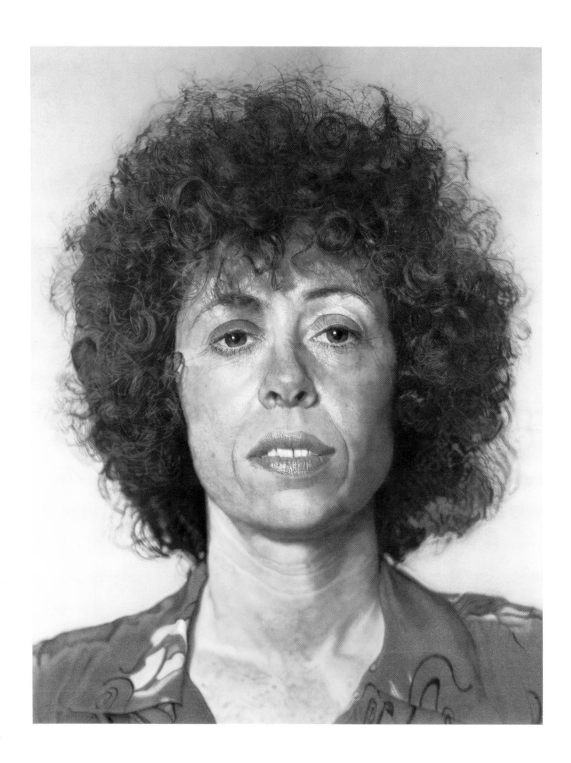

131

Colorplate 49

GERHARD RICHTER (b. 1932)
Ema (Nude on a Staircase), 1966
Oil on canvas, 78 $^3/_4$ × 51 $^1/_8''$ (200 × 130 cm)
Ludwig Museum, Cologne

The first impression is of photography, not painting: every evidence of the human hand is suppressed; paint and color could not be more impersonal if they were printed; even the nude seems photographed by a shaky-handed amateur. The painting looks as banal and matter-of-fact as a snapshot, and all questions of "art" or even "painting" seem irrelevant. Yet closer inspection tells us that the model was by no means slavishly copied, and the composition has been worked out with colors in a careful equilibrium of pictorial values. The creative intervention—changes in what is copied—aims at a distinction between painting and photography and between "picture" and "real." Here the focus has been manipulated to emphasize the central axis and the sharp, clear image of the woman, while the margins are increasingly hazy. This is the key to Richter's attitude toward photography, which is linked to painting as a new mode of seeing. The photograph, to his mind, is a separate and independent source of images entirely apart from traditional art, whose criteria, in fact, it denies. As Richter has put it, the photograph from which he worked "had no style, no composition, no point of view." The result is something new. Reality is no longer reproduced by means of painting but is itself produced as the outcome of a creative process; the picture contains its own reality, which is independent of its model. The distance between painting and photography is, therefore, reinstated. The point of this approach lies in the significance of photographic images, with all their triteness, as models, archetypes, and paradigms of all our images.

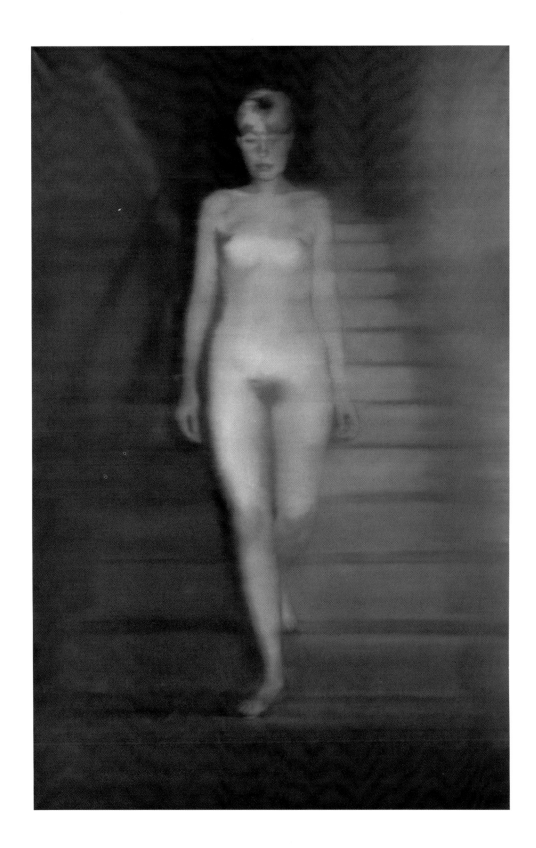

Colorplate 50

FRIEDRICH HUNDERTWASSER (b. 1928)
Shipwreck—Venice Sinking, 1964

Mixed media on paper with hemp, 26 $^7/_8$ × 19 $^1/_4$" (68.3 × 49 cm)
Sprengel Collection, Kunstmuseum, Hannover

Hundertwasser, who changed his name from Friedrich Stowasser by simply replacing the Czech prefix *sto* with its German equivalent *hundert,* stands outside the major lines of contemporary artistic development. True, his roots go back to the Vienna Sezession movement after 1900, but the connection means little because the artist himself thinks not in art-historical categories but in images. He has made his own quiet world which has no points of contact with the real state of things today, except as a reaction against the unpoetic harshness of our time. Art is made a refuge, a poetic enclave in life, set apart for anyone who feels the same way. These dreams in color are visions from a lost paradise to which his work would like to take us back.

Object and ornament are identical in his paintings. Colors possess neither expressive nor formal value. They are laid on one next to the other, rarely mixed, and arranged in decorative patterns that create an ornamental motley array. Content is conveyed through poetic metaphors. Here Venice is drowned in beauty, with the gondola a broadly swaying decorative form through which one sees, as through a magnifying glass, the colored water rising. Here what is and what will soon no longer be are transfigured; neither death nor destruction has a part in it. As Hundertwasser sees it, the task of art is to be a divining rod pointing our way back to those sources that "the bluff of civilization" has plowed under.